IMAGES
of America

DANVILLE

IMAGES
of America

DANVILLE

Todd McGregor Yeatts

ARCADIA
PUBLISHING

Published by Arcadia Publishing
Charleston SC, Chicago IL, Portsmouth NH, San Francisco CA

Printed in the United States of America

Library of Congress Catalog Card Number: 2004110484

For all general information contact Arcadia Publishing at:
Telephone 843-853-2070
Fax 843-853-0044
E-mail sales@arcadiapublishing.com
For customer service and orders:
Toll-Free 1-888-313-2665

Visit us on the Internet at www.arcadiapublishing.com

For Virginia,
My pride and joy.

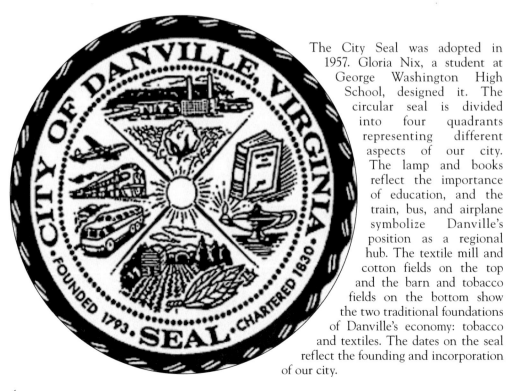

The City Seal was adopted in 1957. Gloria Nix, a student at George Washington High School, designed it. The circular seal is divided into four quadrants representing different aspects of our city. The lamp and books reflect the importance of education, and the train, bus, and airplane symbolize Danville's position as a regional hub. The textile mill and cotton fields on the top and the barn and tobacco fields on the bottom show the two traditional foundations of Danville's economy: tobacco and textiles. The dates on the seal reflect the founding and incorporation of our city.

CONTENTS

ACKNOWLEDGMENTS

This book was made possible by the help of many and the support of countless more. Compiling and selecting photos is an undertaking that can be fascinating and frustrating. If not for others, this would have been impossible task.

It would be easy to simply list those who made material contributions, but perhaps as important as the direct aid was the indirect support. That support, both expressed and felt, gave me the confidence to undertake this project.

I thank my parents, Frances and Rick Yeatts, for choosing Danville as their place to live and for giving my sister and me a loving and supportive home to grow up in. I thank the neighbors of my youth for making Motley Avenue a safe and caring environment. I thank my teachers from Third Avenue Kindergarten to George Washington High School for giving me an education, but more importantly, providing me with an understanding that if you care, you can make a difference.

In particular I want to recognize my family and friends for their contributions in making this project a reality. I want to thank Anne Moore for her assistance and support, Gary Grant for his extensive knowledge of the area, and Laurie Moran and the Danville Pittsylvania County Chamber of Commerce for the use of their photo collection, without which this book would have been empty. In addition, I want to recognize the contributions of Richard Drazenovich, Curtis Calloway, Renee Wyatt, Vaden and Associates, the Danville Public Library, and Susan Beck and Kathryn Korfonta of Arcadia. Lastly, I want to thank those who helped but asked to remain anonymous.

INTRODUCTION

For everyone there is a special place. For some it is the beach; for others it is the mountains; for me, it is Danville. Danville is more than a city; it is a place of good memories, of security, and most importantly, it is my home.

This book is an attempt to provide the reader with an understanding of what makes Danville special by offering glimpses of our city's past, present, and future through photographs. It is not designed to be a thorough history and is not meant to be an authoritative reference. It is a collection of pictures that reflect the people, places, and events that contributed to making Danville one of Virginia's exceptional localities.

Danville is located in South-Central Virginia in the foothills of the Blue Ridge Mountains. The 43.9 square miles that comprise the city are surrounded by Pittsylvania County on all but the southern boundary, shared with North Carolina. Protected from harsh weather extremes, Danville's population of just less than 50,000 enjoys four distinct seasons with an average rainfall of 42.7 inches and an average 8.9 inches of snow each year.

The Dan River, Danville's namesake, flows from west to east through the city. The waters of the Dan originate in the Blue Ridge Mountains and ultimately flow into Albemarle Sound in North Carolina. Col. William Byrd named the river in 1728 while surveying the boundary between Virginia and North Carolina. In 1733, Byrd documented the initials J.H., H.H., and B.B., along with the date of May 1673 on a beech tree. It is believed that the initials were those of John Hatcher, Henry Hatcher, and Benjamin Bullington, traders who were well known to local Native Americans. This is the earliest known presence of non-natives in the area.

Prior to Byrd's survey, two Scottish immigrants, Peter and Ailcey Wilson, built Wilson's Ferry seven miles west of Danville's present location in 1720. Their son, John, became one of Danville's 12 founders. The first settlement of the area now called Danville was by William Wynne, who was deeded 200 acres south of the Dan River by the Virginia colony. The area became known as Wynne's Falls and was used as a north-south crossing of the river by traders.

It is accurate to say that Danville was built on tobacco. The golden leaf was the principal basis for the region's early economy, but the closest inspection stations were in Richmond and Petersburg. In 1793, the Virginia General Assembly was petitioned for a tobacco inspection station to be established at the Dan River. On November 23, 1793, the village of Wynne's Falls became the town of Danville by act of the Virginia Legislature. By 1830, prosperity had allowed Danville to flourish, and the General Assembly authorized its charter on February 17, 1830. On May 21, 1833, Danville's first mayor, James Lanier, and its first council were elected.

Prior to the Civil War, Danville continued to grow, building churches and schools, and by 1856, the town had an established railroad, the Richmond and Danville Railroad, which later became Southern Railway Company. Another important milestone was the establishment of the "Danville System" of selling tobacco at auction. Before the adoption of this system, tobacco was sold in samples while placed in hogsheads. The Danville System utilized piles placed on the floor that could readily be examined by buyers who would bid on the piles during an auction, and soon Danville became known as the "World's Best Tobacco Market."

When the Civil War began in 1860, Danville was a thriving community of approximately 5,000 people. During the war, Danville served as a supply depot, hospital, and rail center. Large numbers of Confederate soldiers, supplies, and war material passed through Danville en route to Gen. Robert E. Lee's Army of Northern Virginia. Because of its location and railroad facility, Danville was chosen as a site to house Federal prisoners. Rather than build a camp for captured Union soldiers, six large tobacco warehouses were converted into prisons. For 15 months, 7,000 officers and enlisted men were held here. Smallpox and dysentery, caused by starvation, led to the death of 1,400 of those prisoners. The bodies were later interred at Danville National Cemetery.

In April 1865, with Federal troops poised to capture Richmond, Confederate President Jefferson Davis and his cabinet boarded a train and headed to Danville. Davis arrived in Danville on April 3 and established the Confederate capital at the home of Maj. William T. Sutherlin. It was here that Davis issued his last proclamation, and on April 10, Davis received word of General Lee's surrender to Gen. Ulysses S. Grant at Appomattox. For its wartime service as the seat of the Confederacy from April 3 through April 10, 1865, Danville will forever be the "Last Capital of the Confederacy."

Following the Civil War, textile manufacturing would come to prominence. The first cotton mill was built in Danville in 1828, but it was in 1882, when six local businessmen formed Riverside Cotton Mills, that an era of textile prosperity truly began. Riverside Cotton Mills would continue to grow and expand, becoming the textile giant Dan River, Inc. (DRI). Today DRI continues to be an industry leader in the manufacture of textile products.

Arguably one of the most infamous train wrecks in history occurred in Danville on September 27, 1903, but it was neither the damage nor the loss of life that made this tragedy so significant. The ballad "The Wreck of the Old 97" immortalized the event and ultimately became the first single to sell a million records in country music history. Today a roadside marker on Riverside Drive in Danville marks the location where engineer Steve Broady and his mail train No. 97 plunged into the creek below the Stillhouse Trestle.

During the 20th century, Danville saw its boundaries expand, its economy diversify, and its population swell. Today, Danville is a tremendous community with a rich history and a bright future. New industries, educational facilities, and innovative technological improvements offer the opportunity for an even brighter tomorrow.

One

TOBACCO

Danville is a city built on tobacco. By act of the Virginia General Assembly in 1793, Danville was expressly founded to serve as a tobacco inspection station. It was the inspections, and ultimately the "Danville System" of auctioning the leaf piles, that allowed Danville to prosper and become the "World's Best Tobacco Market." Tobacco was not just a business but also a way of life that evolved into celebrations, parades, and grand-opening days of the tobacco market.

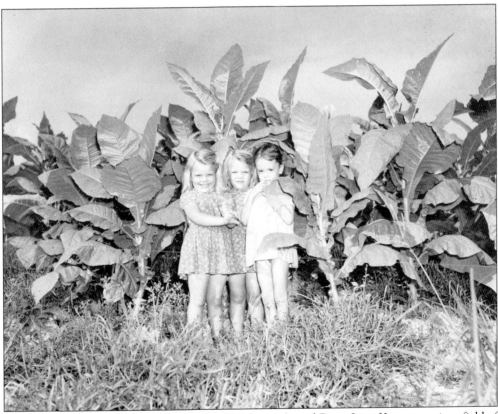

Annie May Gauldin (left), Linda Fay Gauldin (center), and Betty Joan Koger pose in a field of bright leaf tobacco near Danville in 1947.

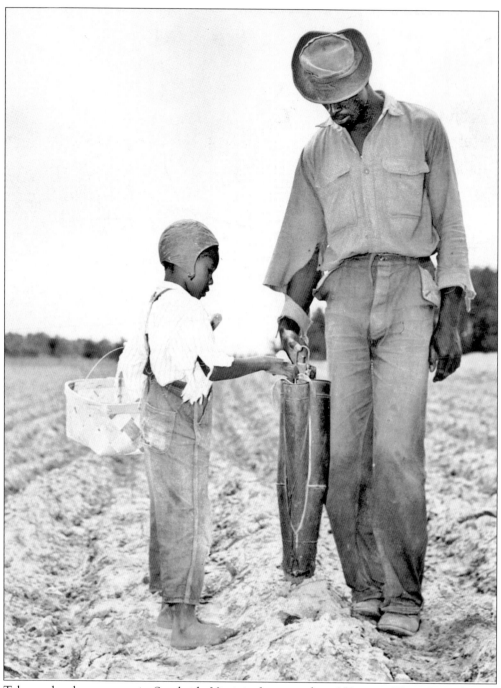

Tobacco has been grown in Southside Virginia for more than 250 years. This photo shows a farmer in a planting bed in the 1920s in Pittsylvania County.

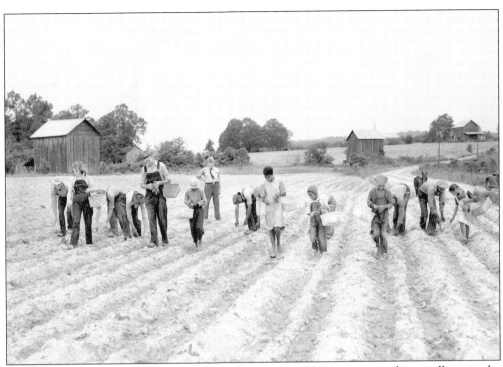

This 1920s-era photo shows workers in a local tobacco field using pegs to place seedlings in the ground. The barns in the background were used for curing when the crop was harvested.

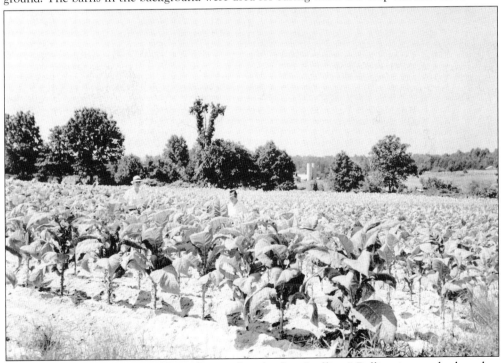

The stalks in this tobacco field are shown after the first "pulling." Pulling is a method used to harvest leaves from the stalk.

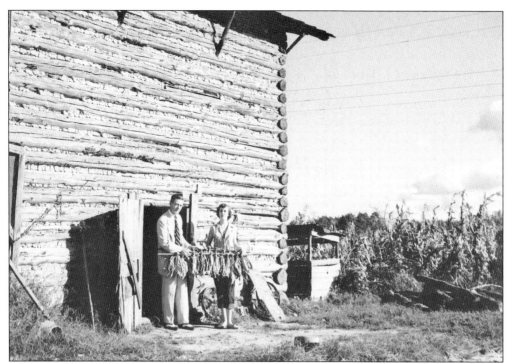

Charles Waddell, the supervisor of sales and secretary of the Tobacco Association, poses with the 1952 Queen of Tobaccoland, Miss Shirley Ann Gravett. They are holding a tobacco stick. Leaves were attached with twine, which allowed the tobacco to be hung in the curing barn.

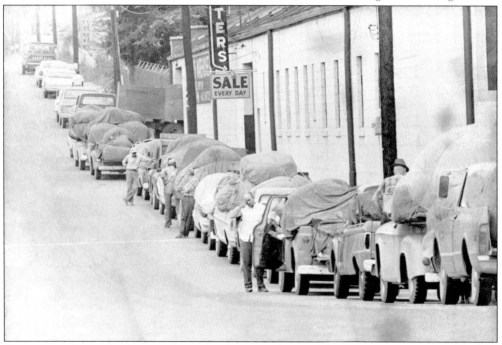

Farmers stand outside their trucks with tobacco in bails while waiting to unload at Planters Warehouse in 1969.

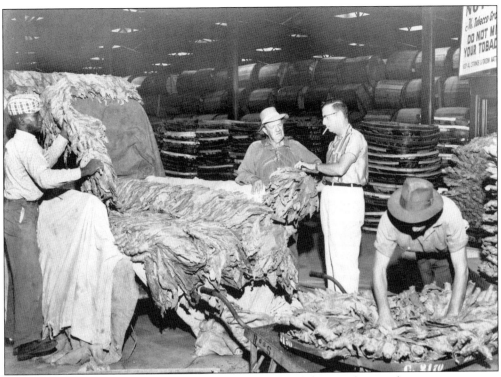

Tobacco was unloaded and placed on baskets inside of the warehouses for inspection prior to auctions.

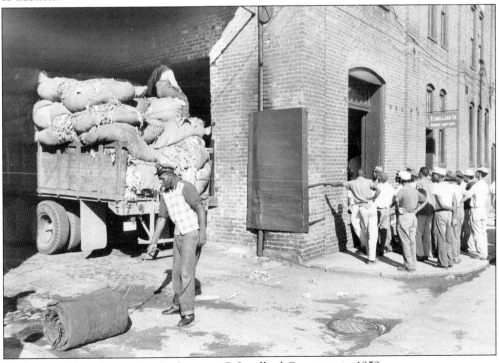

Workers stand ready to unload tobacco at P. Lorillard Company in 1959.

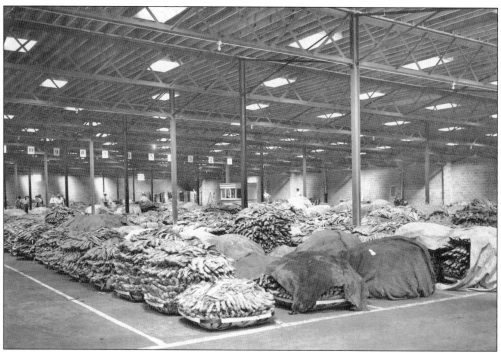

Before auctions could begin, tobacco was placed in rows along the warehouse floor. This Bright Leaf tobacco stands ready for the start of the 1949 auction.

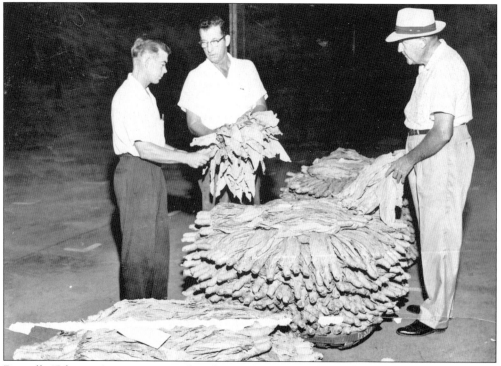

Danville Tobacco Association member George A. Myers Jr. (center) inspects tobacco at Neal's Warehouse in 1961.

Neal's Warehouse was a massive structure along Riverside Drive. It was one of many tobacco warehouses that served farmers from neighboring communities. Neal's Warehouse was destroyed by fire in May 1980.

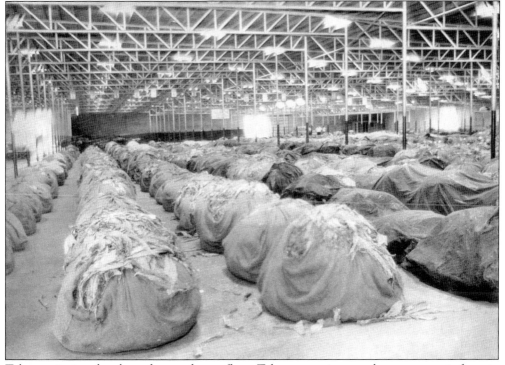

Tobacco sits in piles along the warehouse floor. Tobacco continues to be an economic force in Southside, with more than $49 million worth of the product sold in Danville in 2000.

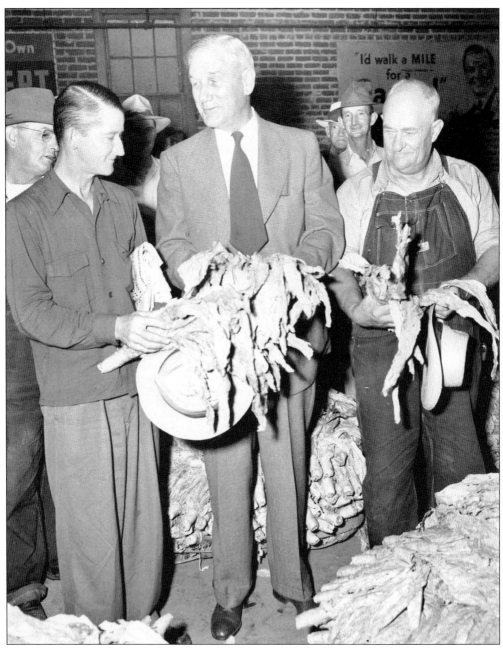

Opening days at tobacco markets were major events. Gov. John S. Battle inspects leaves prior to the opening of the Old Belt Market in Danville in 1950. The Old Belt Market included Southern Virginia and Piedmont North Carolina farms. Most tended to be small and had rolling clay fields well suited for tobacco.

Local farmers celebrated the opening of the tobacco market. It was an opportunity to see friends and to take a break from the hard work of the tobacco-growing season.

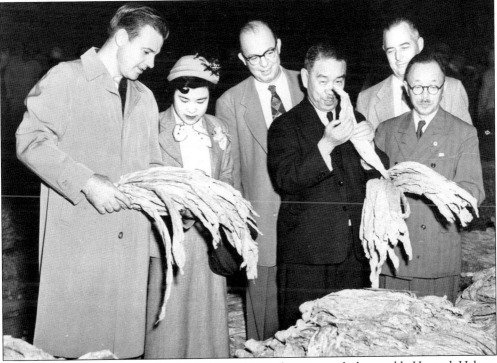

"The World's Best Tobacco Market" drew visitors from around the world. Howard Hylton, executive vice president of the chamber of commerce, is shown here with a Japanese delegation.

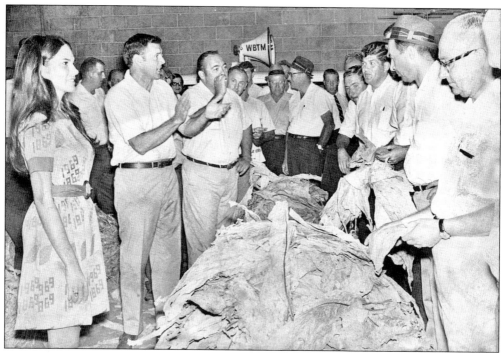

Bob Cage auctions tobacco on opening day of the market in 1969. Cage was one of the most well-known auctioneers, and his career, which lasted more than 45 years, included winning the World Tobacco Auctioneering Championship at Danville's annual Harvest Jubilee Festival.

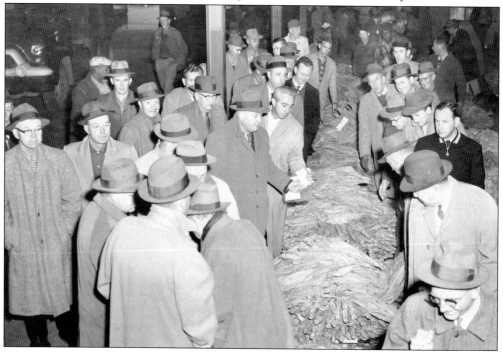

Tobacco auctioneering began in Danville in 1858. The "Danville System," as it was known, became used in warehouses across the South.

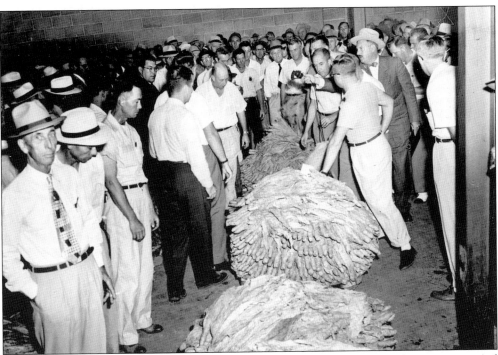

The chanting of the tobacco auctioneer made tobacco sales an event for spectators and participants alike. Fourteen major warehouses once held annual tobacco auctions.

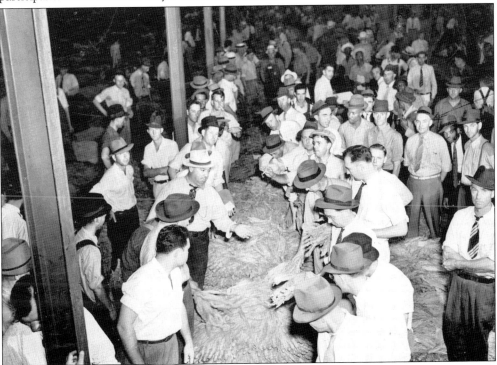

Large crowds gathered for tobacco auctions each year. Today, auctions have become mostly memories, as farmers contract directly with tobacco companies.

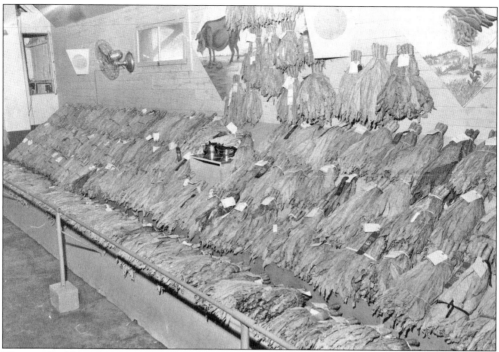

The pride felt for the quality of Danville-area tobacco is evident in this display at the 1959 fair.

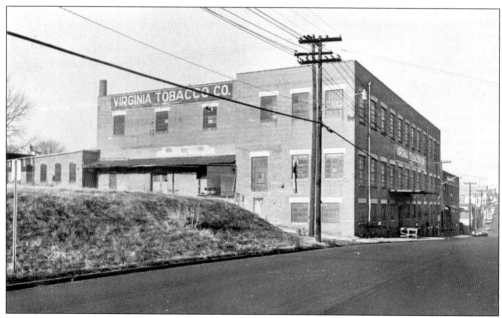

The Virginia Tobacco Company was located on Craghead Street. It was one of the many tobacco companies that once flourished in Danville. The warehouse later became the National Tobacco and Textile Museum.

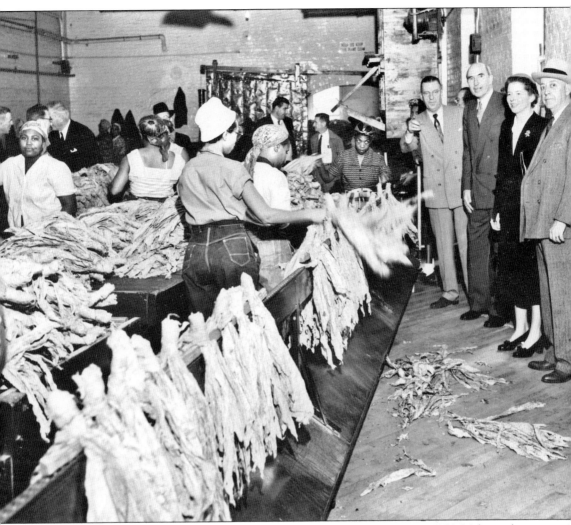

Sir Roger and Lady Alice Davis Makins tour Imperial Tobacco Company in 1956. Makins, the British ambassador to the United States, was one of many prominent individuals that came to see the "World's Best Tobacco Market."

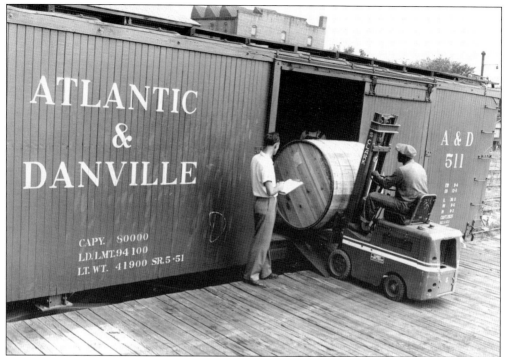

After auctions, tobacco was transported in hogsheads for processing. A hogshead contained an average of 1,100 pounds of re-dried tobacco. Workers are shown here loading tobacco on an Atlantic and Danville railcar.

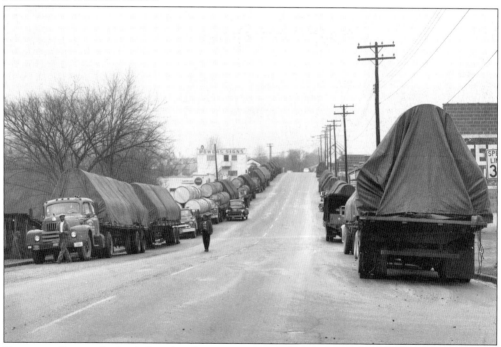

Tractor-trailer trucks loaded with tobacco waiting to be stored and processed line Industrial Avenue following the 1958 season.

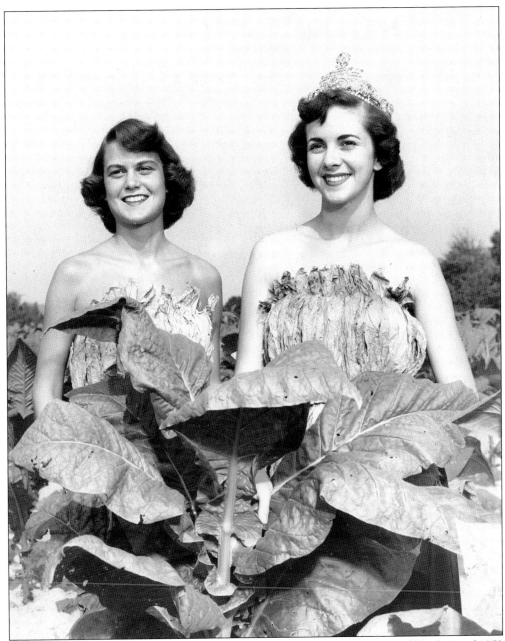

The 1952 Queen of Tobaccoland Shirley Gravett (right) and Miss Danville Bright Leaf 1953 Diana Dibble stand in a tobacco field near Danville.

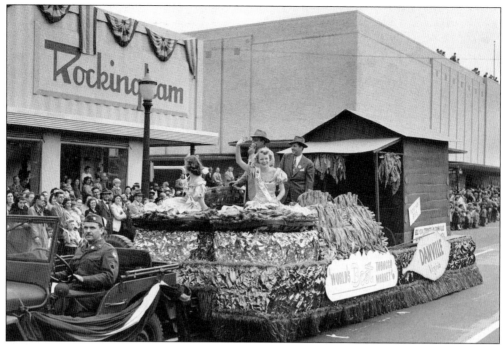

Richmond, Virginia, held its first Tobacco Bowl Festival in 1949. The "World's Best Tobacco Market" was featured in the parade. Miss Danville Jeanne Dyer, Miss World's Best Tobacco Market Anne Glass, auctioneer Butch Chandler, and secretary of the Danville Tobacco Association George Myers Jr. rode the float.

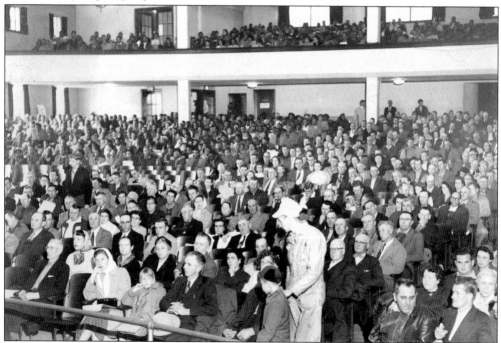

The Old Belt tobacco growers held annual meetings in the City of Danville. Farmers and their families crowded into the city auditorium for the 12th annual meeting in 1956.

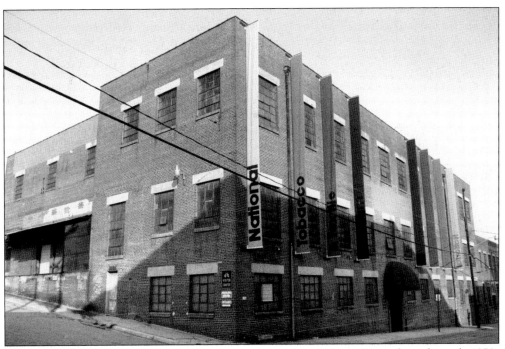

The National Tobacco and Textile Museum was located at 614 Lynn Street from the early 1970s through the 1980s.

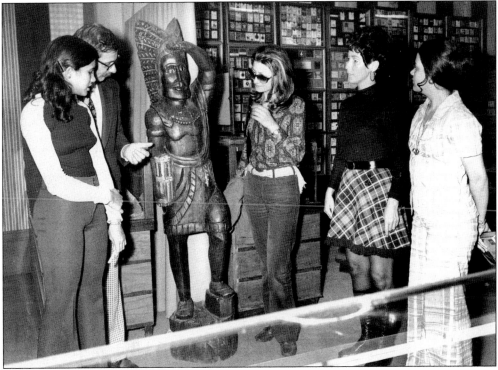

Visitors to the National Tobacco and Textile Museum were offered the opportunity to view the two industries most important to Danville's economic well-being.

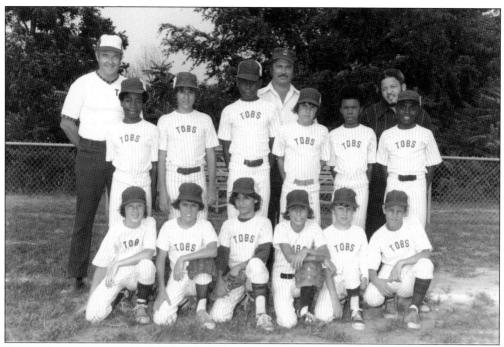

Tobacco's importance in Danville allowed creative ways around rules that prohibited tobacco companies from sponsoring little league baseball teams. Pictured here is the 1977 Dibrell "Tobs" Commonwealth League Majors team sponsored by Dibrell Tobacco Company.

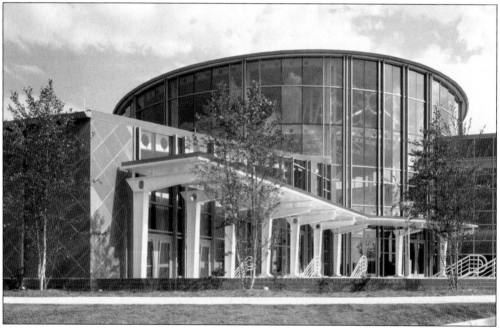

Tobacco continues to play an important role in Danville today and will continue to play a major role into the future. Danville and Pittsylvania County used proceeds from Virginia's Tobacco Indemnification and Community Revitalization Commission to build the Institute for Advanced Learning and Research.

Two

TEXTILES

The textile industry in Danville can be traced back to 1828, but it was not until 1882, when six local businessmen founded Riverside Cotton Mills, that textiles became the second leg of Danville's economy. Over the next century, Riverside Cotton Mills would grow and prosper, becoming the largest single-unit textile mill in the world. Today Dan River, Inc. (formerly Riverside) remains an industry leader in textile manufacturing.

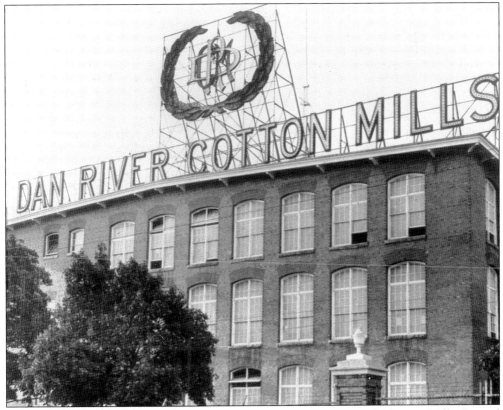

In 1882, six local citizens formed a stock company known as Riverside Cotton Mills. Several name changes later, that company would become Dan River, Inc. The company continues to manufacture textiles today.

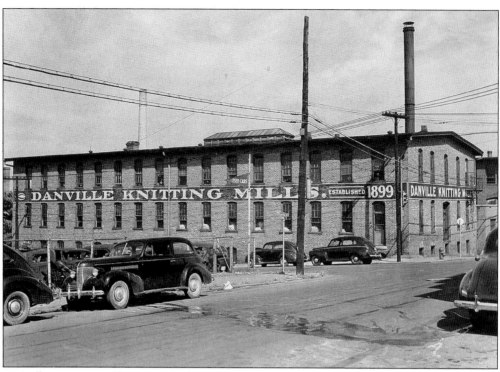

Danville Knitting Mills was established in 1899. It was a manufacturer of seamless hosiery.

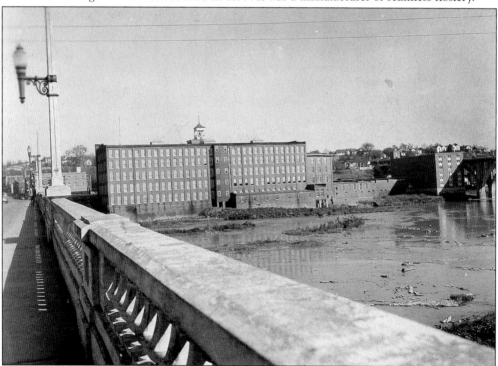

The Riverside division of Dan River, Inc. was located on both the north and south banks of the Dan River. The building pictured here no longer exists.

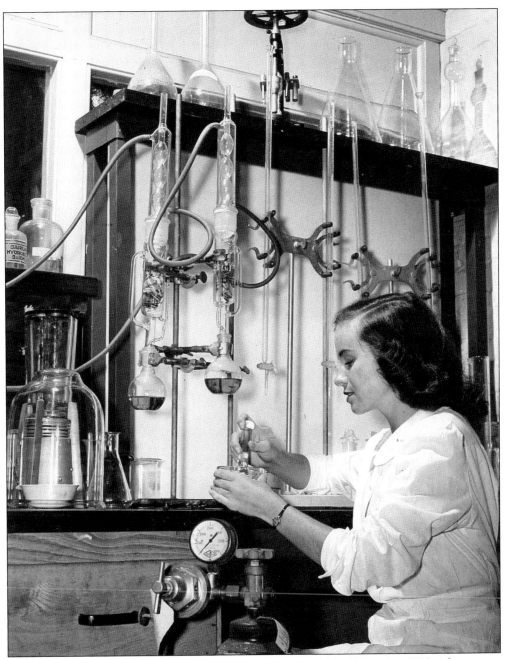

This 1950s photo shows work being done in the laboratory of Dan River, Inc. DRI is the current name of the textile giant that began as Riverside Cotton Mills in 1882. In 1909, a merger changed the name to Riverside and Dan River Cotton Mills, Inc. In 1964, it was changed to Dan River Mills, Inc., and it became DRI in 1970.

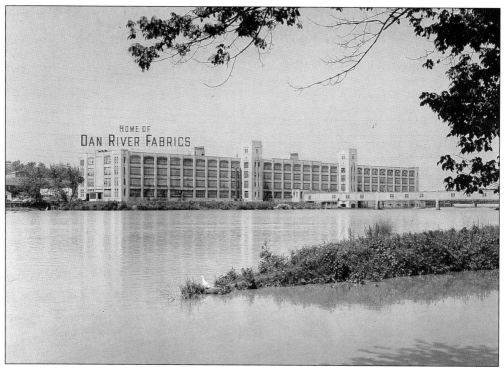

Looking south across the Dan River, the Riverside division's "Home of Dan River Fabrics" sign was a familiar sight. The sign was heavily damaged during a tornado in 2004.

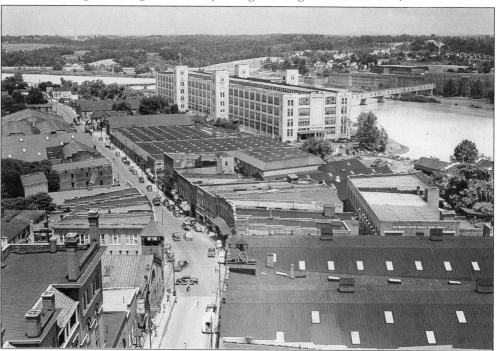

This 1940s view of the Riverside division shows a dramatically different streetscape than that which exists today. Many of the businesses located along Memorial Drive no longer exist.

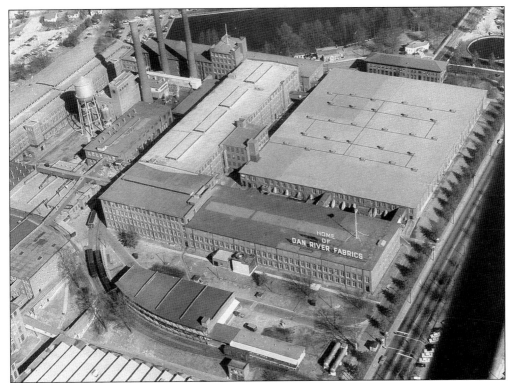

This aerial view was taken in 1960. It shows part of the Schoolfield division of Dan River, Inc.

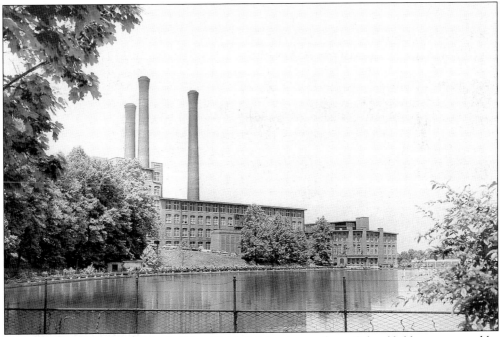

The pond located at Dan River's Schoolfield division is seen here. Schoolfield was annexed by the city of Danville in 1951. Before annexation, it was a company-owned textile mill village that dated from 1903.

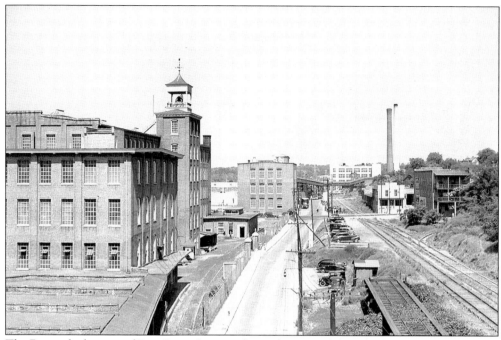

The Riverside division of Dan River, Inc. was located in one of the most historically significant areas of the city. It was the sight of the company's first mill and also the location of the wreck of the Old 97.

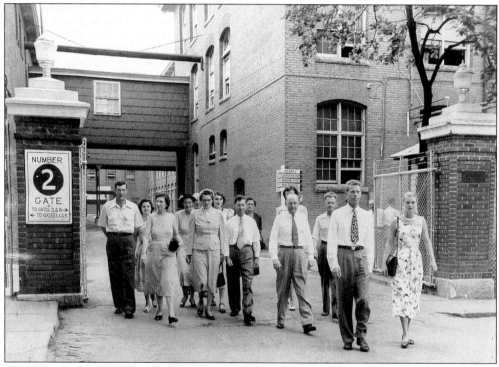

Dan River, Inc. once offered daily tours of its production areas. Visitors are pictured here leaving Schoolfield division Gate Two.

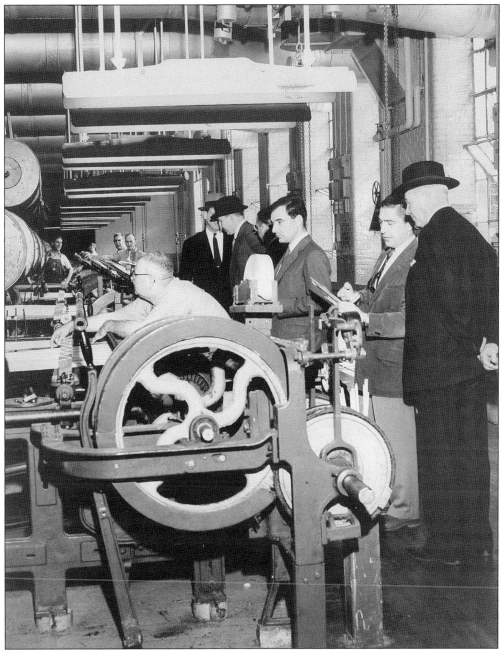

Great Britain's ambassador to the United States, Sir Roger Makins, toured Dan River, Inc. during his visit to the city in 1956. Dan River, Inc. was the city's largest employer throughout the 20th century.

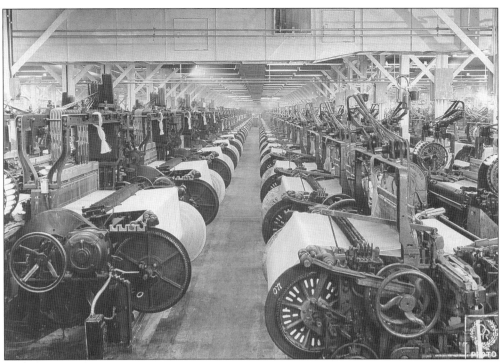

This interior photo of Dan River, Inc. shows the weave room.

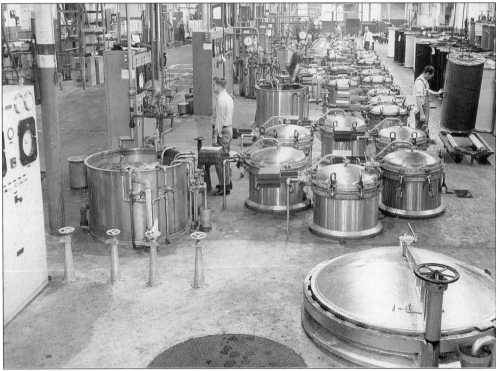

The beam-and-package dye installations featured Gaston County combination beam-and-package dye machines and Theis drying machines.

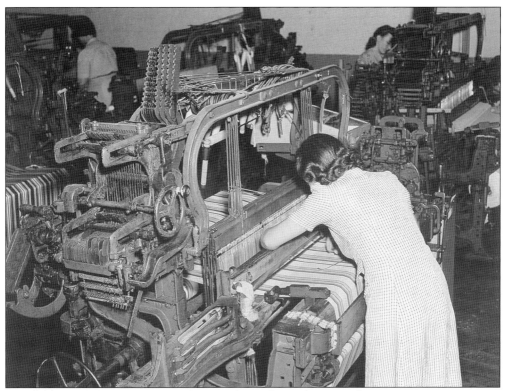

In the weave room, a weaver ties a knot as dress fabric is being made.

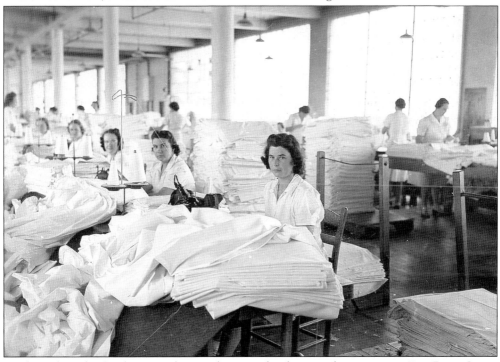

Workers place the finishing touches on sheets in the sheeting department at Dan River, Inc.

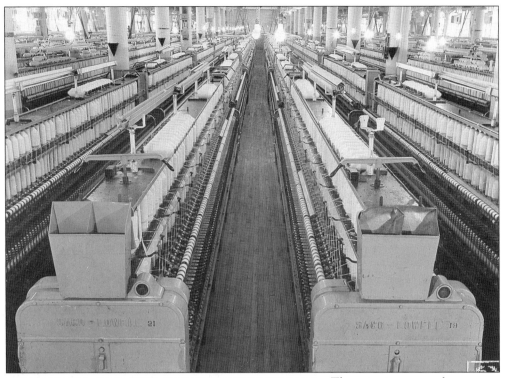

The spinning room above shows the magnitude of Dan River's operation.

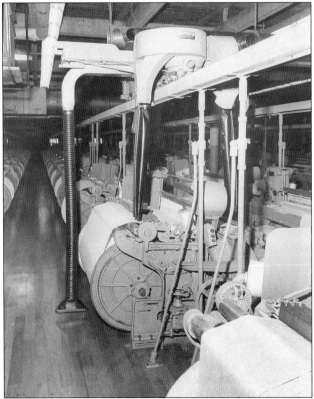

This 1959 photo shows Dan River's new Draper shuttleless looms.

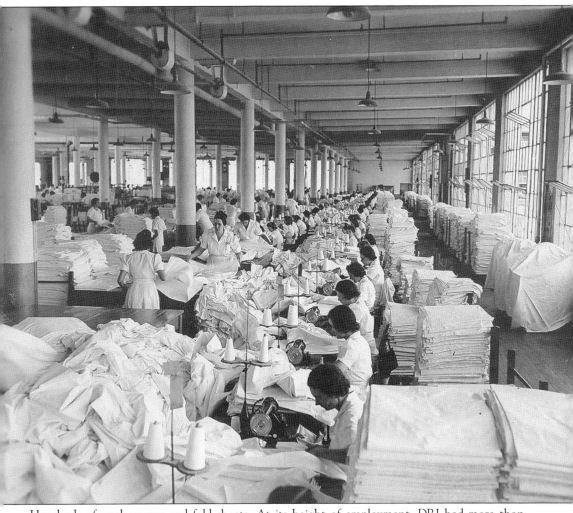

Hundreds of workers sew and fold sheets. At its height of employment, DRI had more than 19,000 employees in 33 plants throughout the Southeast.

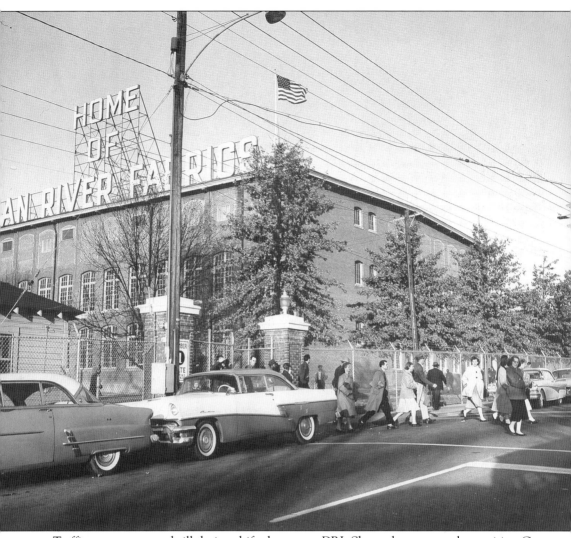

Traffic came to a standstill during shift changes at DRI. Shown here are workers exiting Gate One at the Schoolfield division.

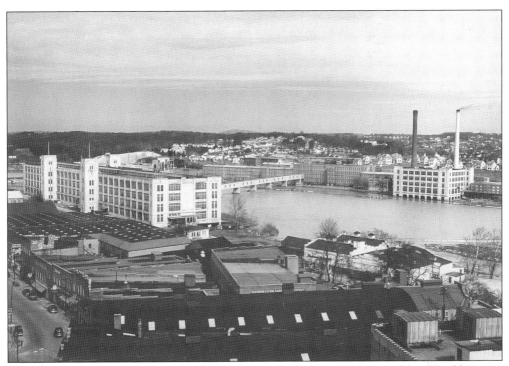

This view, looking north, shows Dan River's Riverside division. The original brick buildings are on the north bank of the river.

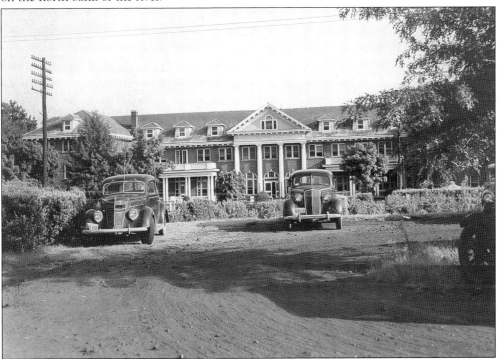

Hylton Hall continues to serve as one of the administrative buildings of DRI. This picture was taken in 1947.

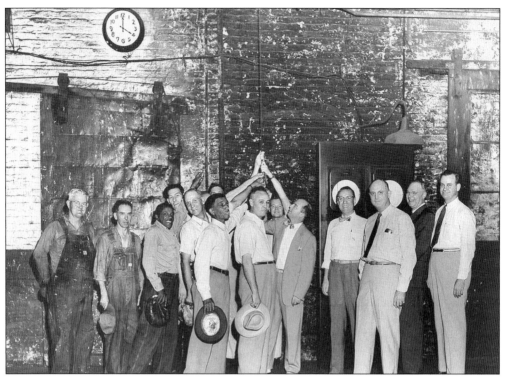

On August 31, 1951, the Schoolfield Mill whistle was sounded for the last time. Workers gather around the pull cord for the final sounding. Modern conveniences such as electric alarm clocks and telephones took away the need for the once-familiar call to work.

A notice posted in the factory read: "Effective as of August 31, the whistle will no longer be blown at the Schoolfield and Riverside Divisions. The need for blowing the whistle has passed and the discontinuance of this practice will be a decided contribution toward a quieter city."

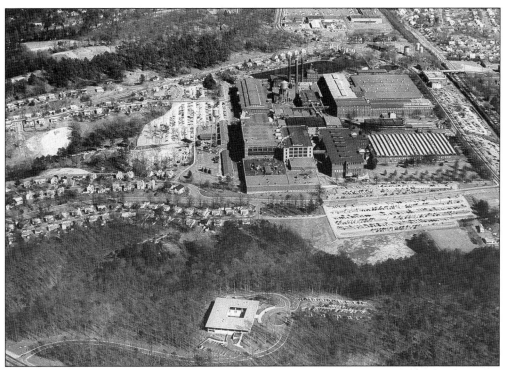

DRI executive offices are shown in the foreground of this 1968 aerial photo, which also shows the Schoolfield division.

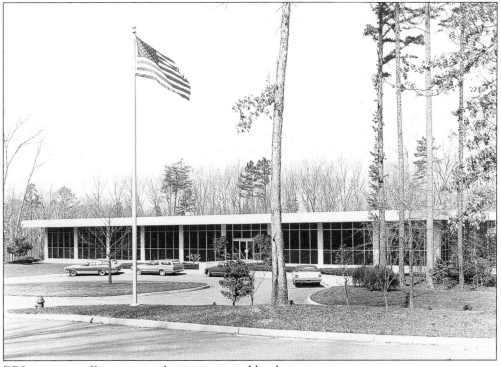

DRI executive offices are seen here in a ground-level view.

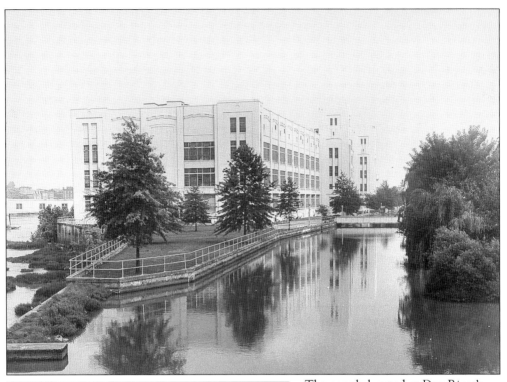

The canals located at Dan River's Riverside division once served to transport goods.

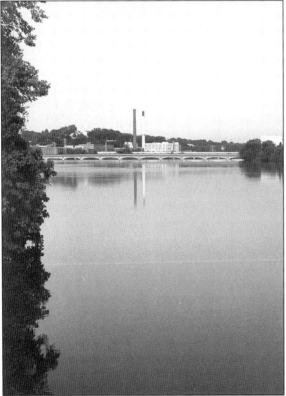

The smoke stacks of Dan River's Riverside division reflect in the waters of the Dan River. This reflection and the stacks serve as a reminder of Danville's textile legacy.

Three

DOWNTOWN

The heartbeat of any community is its downtown. Historically, Danville's downtown was the commercial and retail center of the city. Theaters, restaurants, civic organizations, and parades made it a recreation destination. Like most cities in the United States, the rise of malls and suburban shopping centers led to the decline of traditional Main Street shops and businesses. Revitalization efforts are well underway in Danville in an effort to begin a new era for the downtown area.

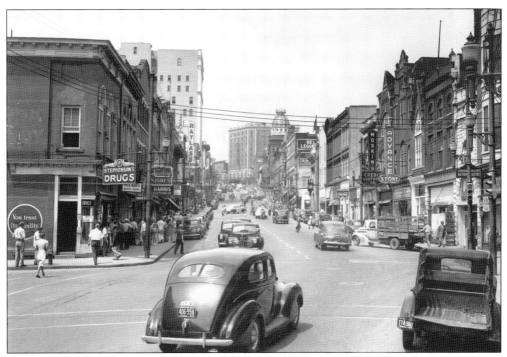

The bustle of downtown Danville is evident in the congestion on the roads and sidewalks in this 1940s era photo.

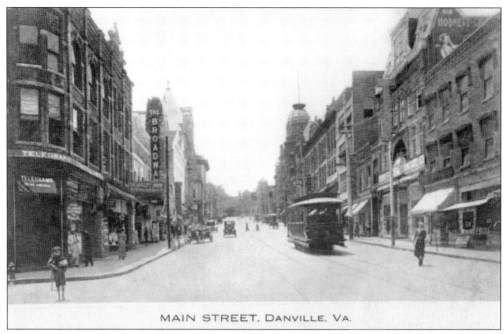

MAIN STREET, DANVILLE, VA.

Downtown Danville featured many movie theaters. One of the most famous was the Lea Theater. It was built on the site of the Broadway Theater to the left in this photo.

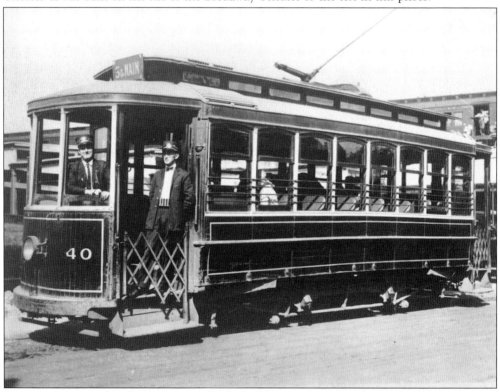

Streetcars were used as the primary method of public transportation beginning in 1888. Busses replaced the streetcars in 1938.

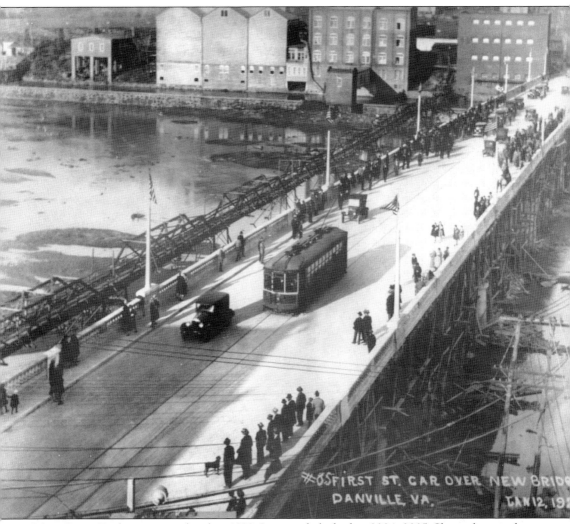

Main Street Bridge was completed in 1928. It was refurbished in 2004–2005. Shown here is the first streetcar to cross the newly opened structure.

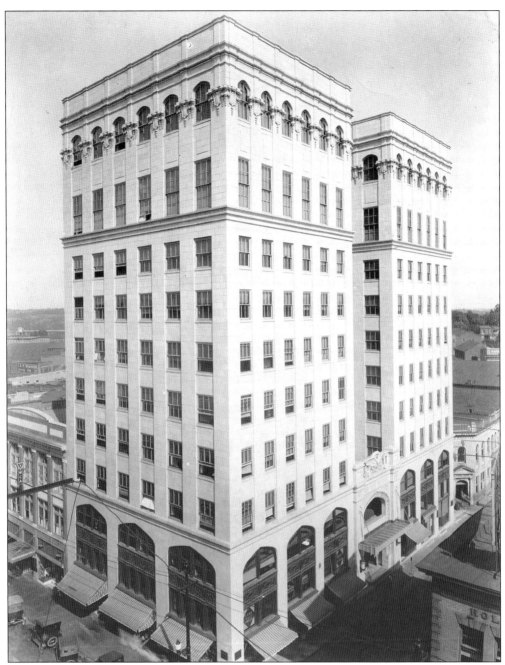

The Masonic Temple was built in 1922. It was the tallest city building and remains so today, more than 80 years later. The Masonic Temple is the third Masonic hall to sit on the corner of Main and South Union Streets. In 1852, the first Masonic hall was built on the site. In 1901, that structure was replaced by a second building, which burned in 1920.

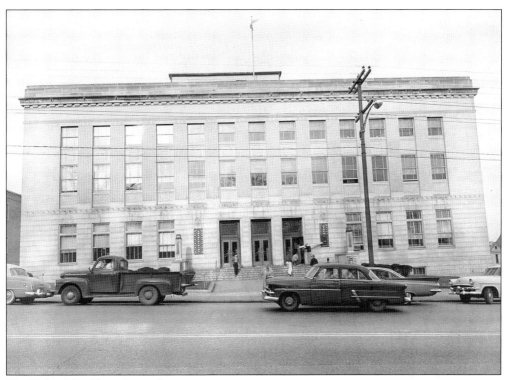

The Federal Building, located in downtown Danville, houses the United States Post Office and the Federal Court. It was built in 1932.

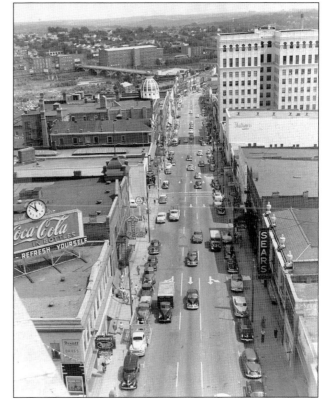

Looking north down Main Street, this 1955 photo shows Sears on the left and what today is the Clement & Wheatley Building. Main Street Bridge and the Riverside division of Dan River Mills can be seen in the upper left.

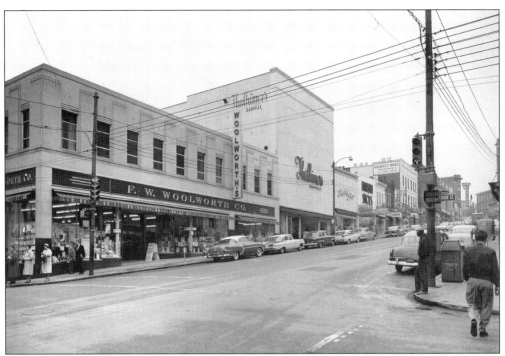

F.W. Woolworth Company was located at the corner of Main Street and South Union Street. Talhimers department store was located next door.

Retail shops on the ground floor of the Masonic Temple can be seen here, along with heavy pedestrian traffic.

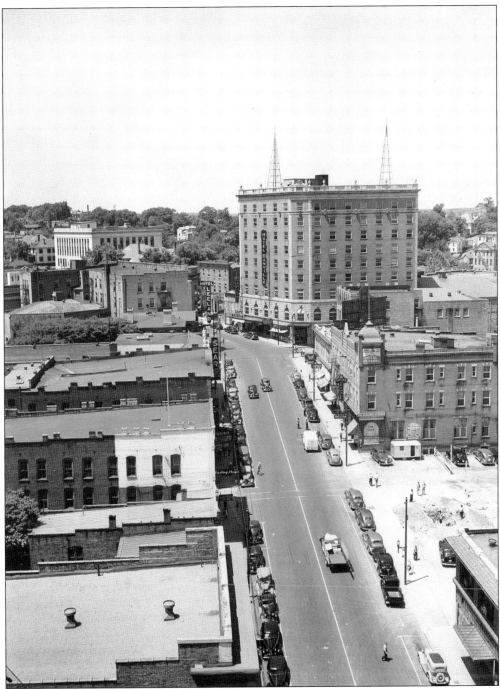

Looking south along Main Street in downtown, Hotel Danville can be seen at the top of the hill. The hotel was built in 1927 and featured a retail store and a movie theater. The hotel operated until 1975. WBTM radio towers can be seen on the rooftop. WBTM stood for "World's Best Tobacco Market" and "World's Biggest Textile Mill."

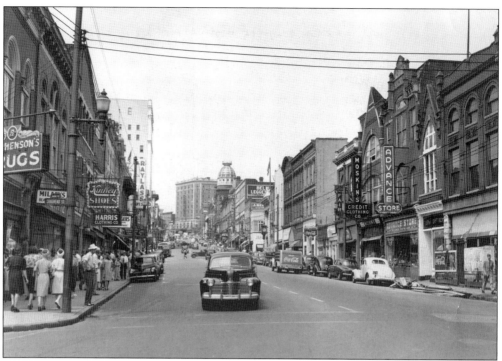

A street-level photo looking south up Main Street shows the variety of businesses available for citizens.

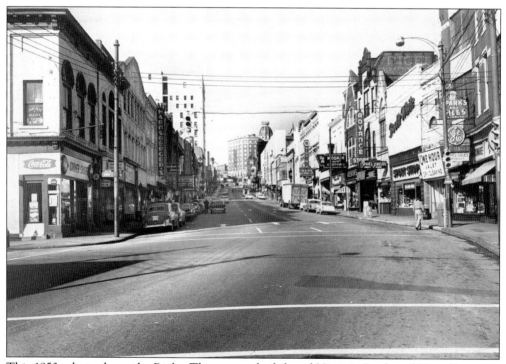

This 1950s photo shows the Rialto Theater on the left and Virginia Bank and Trust Company on the right.

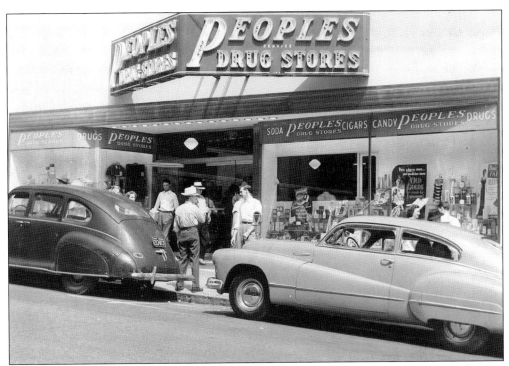

Peoples Drugstore was one of the many businesses that operated downtown during its heyday. This photo was taken in 1948.

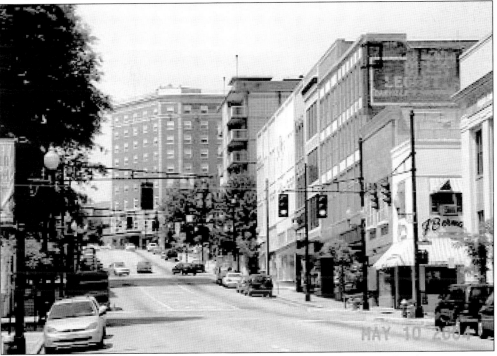

Today a major revitalization effort is underway in the downtown area. Many façade improvement projects have been undertaken and numerous interior improvements have occurred.

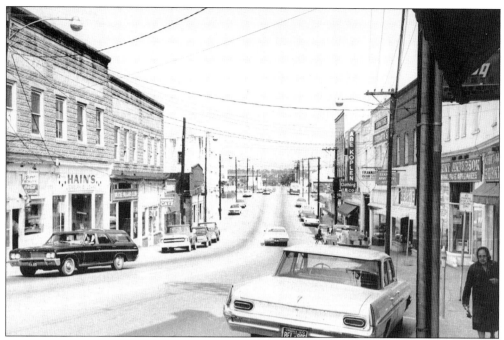

In addition to Main Street, Union Street is an important part of downtown. Several landmark businesses, such as Abe Koplen Clothing Company, Franklin's Discount Store, and Beanies Army-Navy Store, are located there.

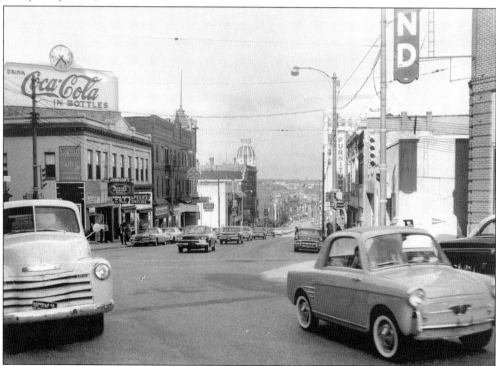

Main Street traffic has been two-way and then one-way; today it is two-way once again. In 1960, cars were only able to travel south on Main Street.

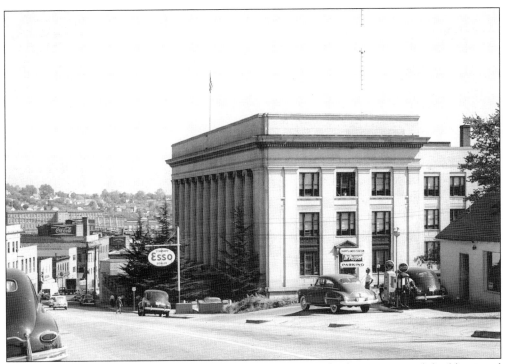

Danville City Hall was built in 1927. Originally, it was both a municipal building and courthouse. Prior to 1927, the municipal building was located at the site now occupied by the Hotel Danville.

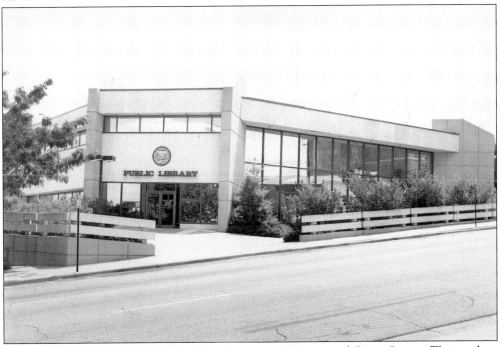

The Danville Public Library is located at the corner of Patton and Court Streets. This modern facility houses more than 130,000 volumes.

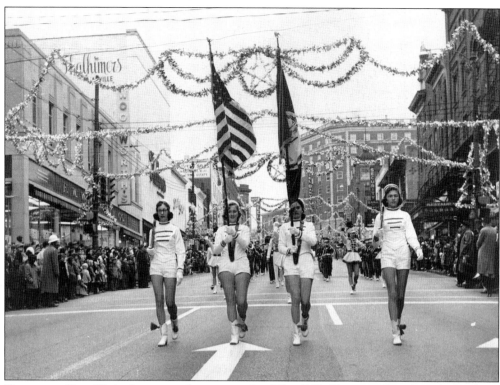

Downtown Danville is the scene of many parades. The 1958 Christmas Parade is shown here. Large crowds line both sides of Main Street.

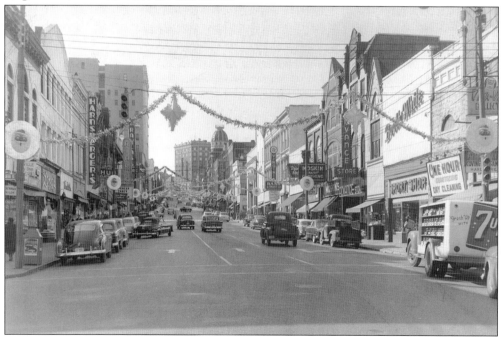

The holiday season is a time for decoration downtown. Decorations and lights have been placed there for more than 60 years, as this 1950s photo reveals.

The River City Center was completed in May 2004. It was the city's benchmark renovation project. The River City Center is the former Belk Leggett department store. The renovation removed the metal siding from the exterior of the building and exposed the windows and brick as they originally appeared.

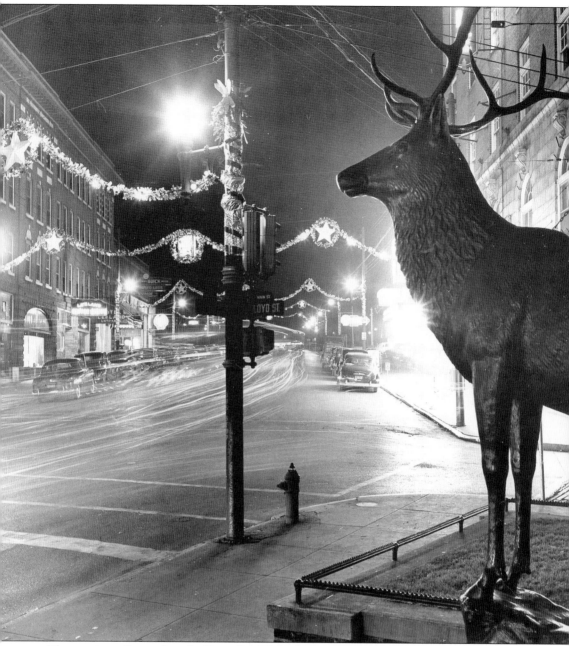

The cast-iron elk guarding the Danville's Elk Lodge has watched over Main Street for more than 90 years. The Lodge celebrated its 100-year anniversary in Danville in 1992.

Four

CITY GOVERNMENT

Danville operates under a council-manager form of government. There are nine council members elected at large to four-year terms. The council elects the mayor and vice-mayor from their ranks. In addition, the council appoints a city clerk, city attorney, and city manager. The city manager serves as the chief executive officer of the city and appoints all executive department heads and key personnel.

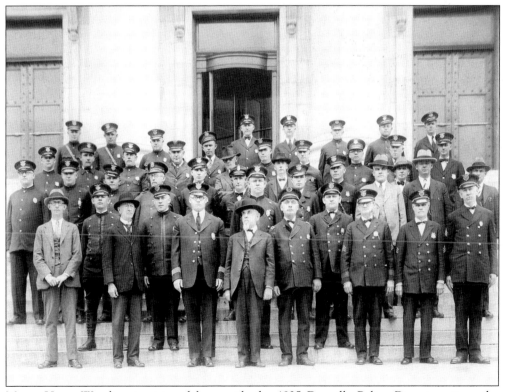

Mayor Harry Wooding is pictured here with the 1925 Danville Police Department on the steps of city hall. Wooding, a veteran of the Civil War, served as the mayor of Danville for 46 consecutive years.

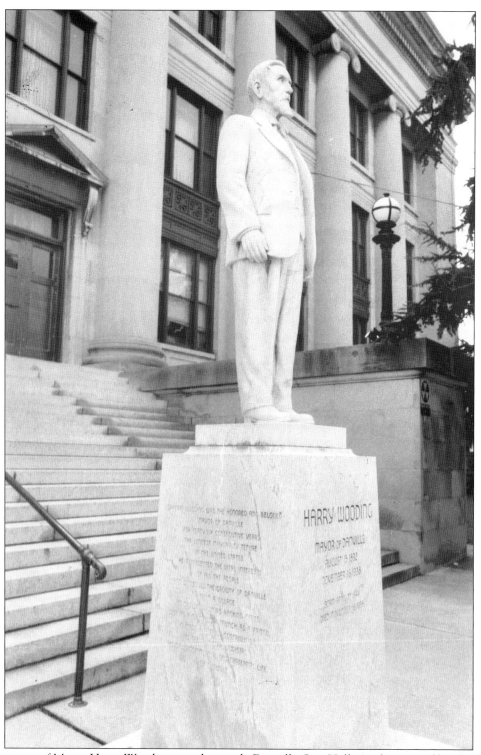

A statue of Mayor Harry Wooding stands outside Danville City Hall. At the time of his death in 1938, Wooding had the longest uninterrupted tenure as mayor in the United States.

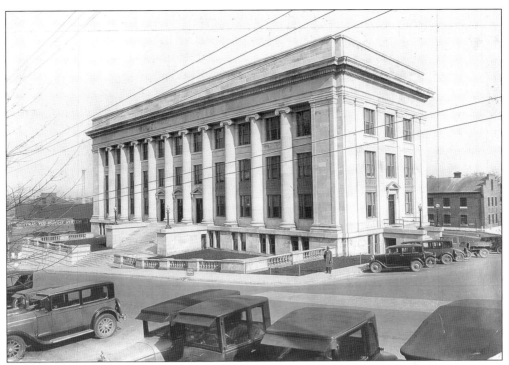

The Municipal Building was built in 1927. This photo was taken in 1935 and offers a view of the city jail on the right side.

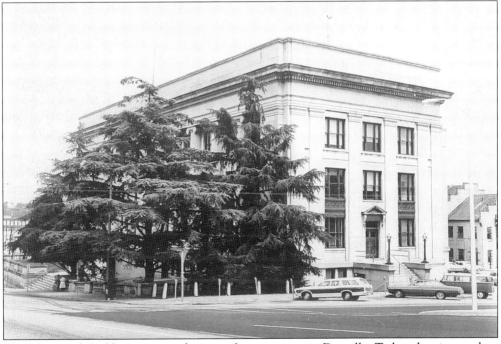

The Municipal Building remains the seat of government in Danville. Today, the city employs more than 1,100 individuals in 12 departments and a variety of offices. This photo from the early 1970s shows the building as it appears today.

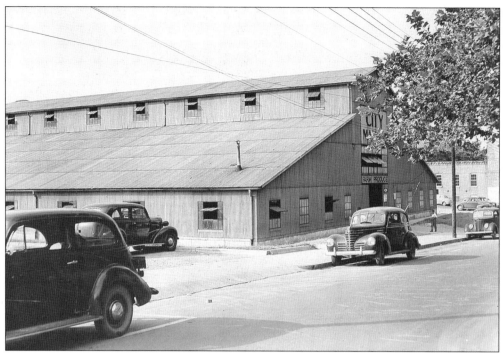

Danville City Market was originally located on Spring Street and provided a place for local farmers to sell produce to citizens.

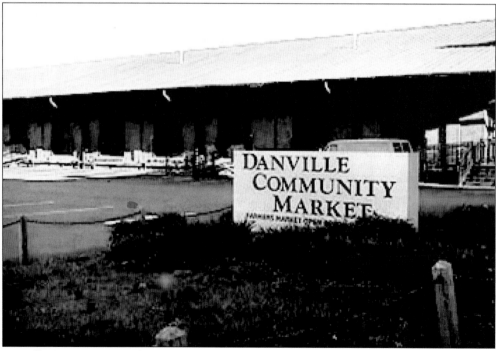

Danville Community Market is located on Craghead Street in the Crossing. The Community Market is open from May to October for the sale of produce, baked goods, and crafts. The facility, a renovated Southern Railroad freight depot, is also used for special events.

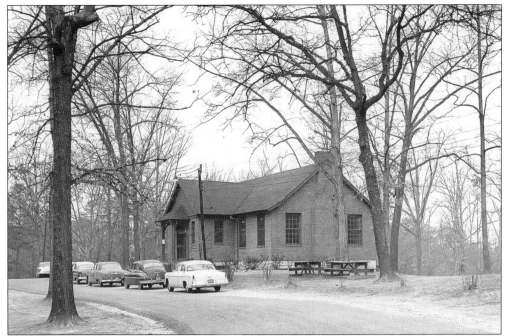

Ballou Park is one of Danville's two major parks. Its 107 acres feature tennis courts, walking trails, and ball fields, and it is the site of the annual Festival in the Park celebration. This 1959 photo shows the former Danville Nature Center, which is used today as the Senior Citizen Center at Ballou Park.

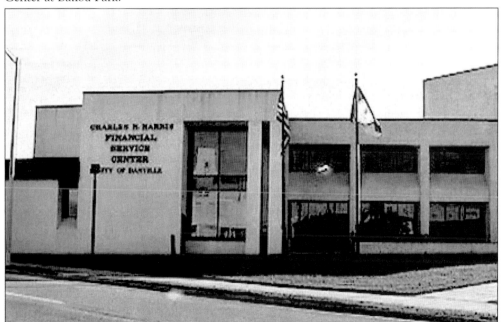

The Charles H. Harris Financial Service Center is located on Memorial Drive. It serves as the office of central collections, utility customer service center, and office of the commissioner of revenue. It was named in honor of Charles Harris, Danville's first African-American mayor. After serving 20 years on the city council, Harris was elected mayor in 1980.

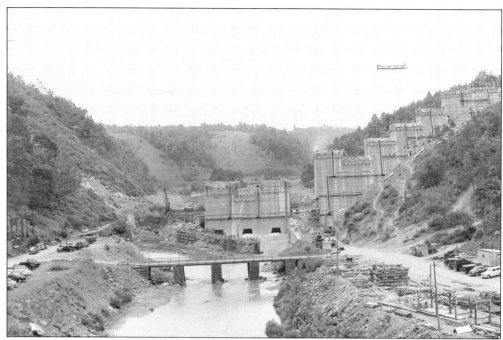

The City of Danville owns 3,600 acres housing the Pinnacles Hydroelectric Facility in Patrick County. The facility includes 2 dams and reservoirs, related pipelines, and a 10-megawatt power plant. This photo shows construction of one of the dams.

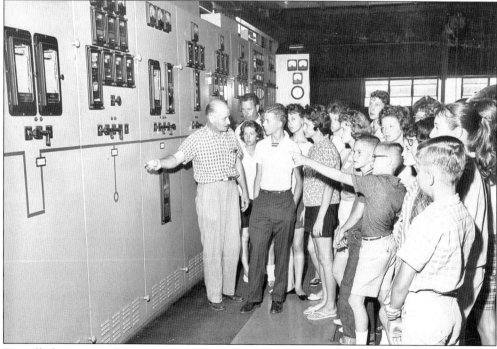

Danville has operated its own electric distribution system since 1886. Today, Danville is the only city in Virginia to offer all major utility services: electric, gas, water, and wastewater. Above, students tour the Brantly Steam Plant.

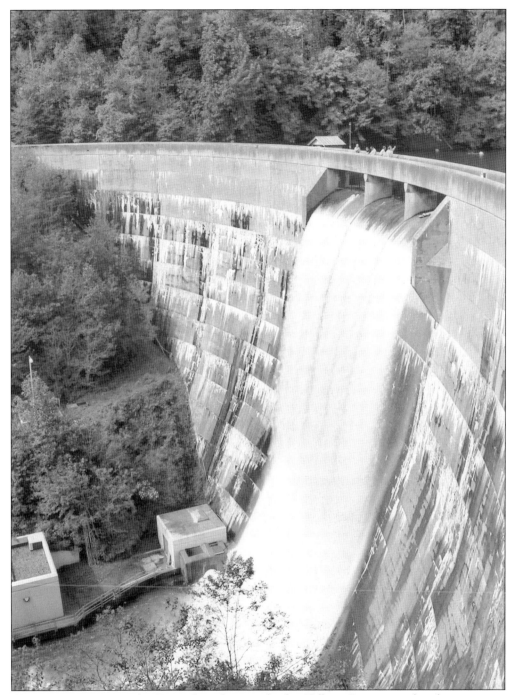

The Townes Dam at the Pinnacles, along with the Talbert Dam, provides the reservoirs necessary to generate electric power. The Pinnacles facility produces five percent of Danville Utility's electric supply needs.

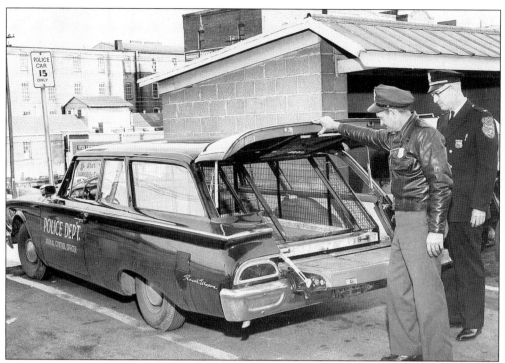

Police chief J.C. Garrett inspects the city's new dogcatcher wagon in December 1958. The Danville Police Department was the first police department in Virginia to install a radio patrol system in its cars in 1935.

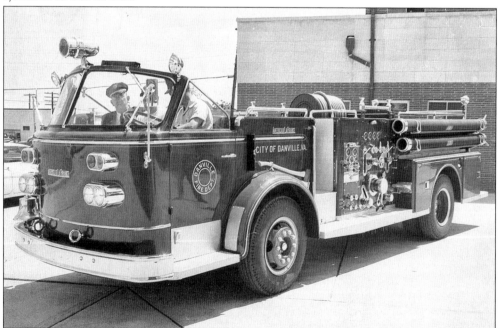

In 1960, Danville received a new open-air fire truck, shown here at Station 5. Danville's ISO-2 rated fire department operates seven stations throughout the city, a 24-hour crash fire and rescue service at the regional airport, and a Regional Hazardous Materials Team.

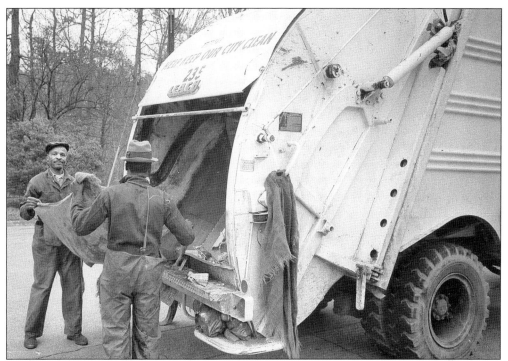

This 1973 photo shows city sanitation workers tossing trash into a truck. Crews from Danville Public Works Department continue to collect residential refuse and yard waste today.

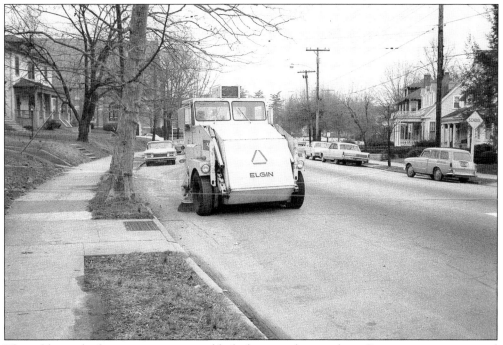

The public works department is responsible for keeping the city clean. Street-sweepers were used to remove debris and eliminate hazards. This street-sweeper was operating on West Main Street near Lockett Street in 1973.

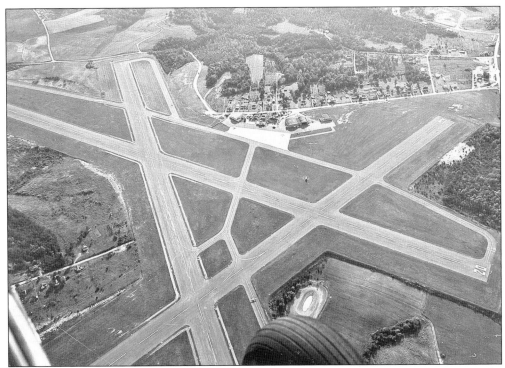

The City of Danville's department of transportation operates Danville Regional Airport. The airport features two active runways. The largest was extended to 6,500 feet in 1998. This photo was taken in 1961.

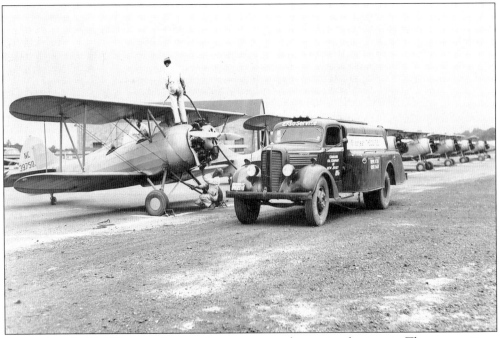

Approximately 30,000 annual operations occur at the regional airport. These operations include refueling, which is pictured in the 1930s-era photo above.

Five

BUSINESS AND INDUSTRY

Tobacco and textiles are the traditional industries associated with Danville, but during the latter part of the 20th century, Danville began to diversify its economic base. The city operates Airside and Riverview Industrial Parks and has partnered with Pittsylvania County to establish the Cyber Park and the Danville/Pittsylvania County Regional Industrial Park, known as Cane Creek Centre. Tires, glass, and food processing have recently been joined by industries focusing on polymers and nanotechnology.

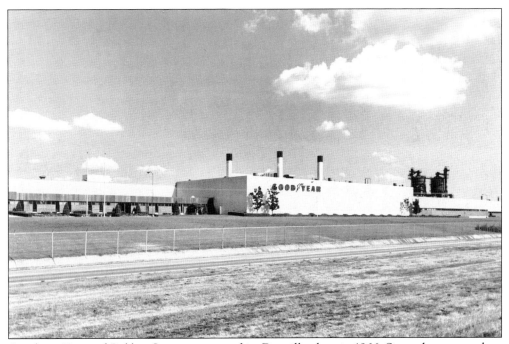

Goodyear Tire and Rubber Company opened its Danville plant in 1966. Since then, more than 19 expansions have allowed the Danville plant to become the largest truck and aircraft tire manufacturing facility in the world.

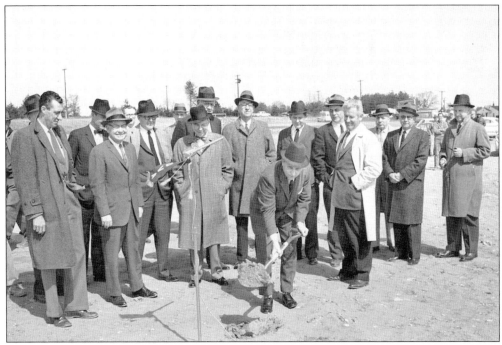

Mayor Julian Stinson breaks ground at Nor-Dan Shopping Center on March 16, 1961. Also pictured are William H. Jefferson Jr., C. Brooke Temple, C. Howard Hylton, T. Edward Temple, Fletcher D. Harris, James T. Whitehurst, Hedrick Johnson, C. Stuart Wheatley, Emerson J. Pryar, and Charlie Bradley.

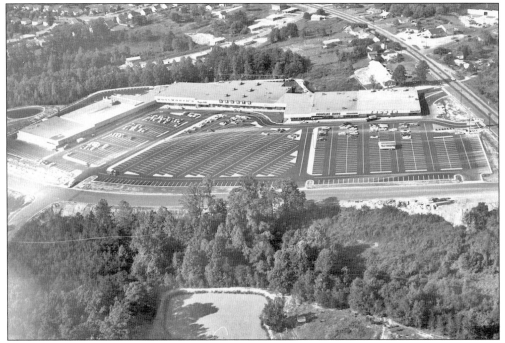

Nor-Dan Shopping Center opened in 1961. Its stores included Winn-Dixie, the Collins Company, Woolworth's, Grants, Peoples Drug, and Kroger.

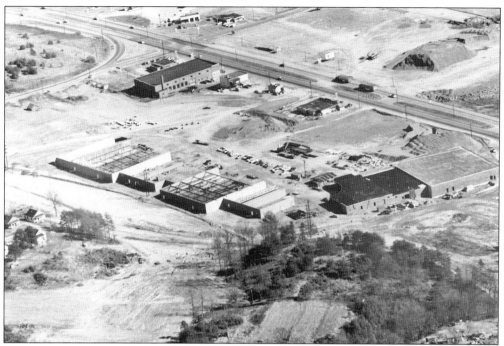

Riverside Shopping Center was built in 1960. This view was taken looking south towards the Dan River.

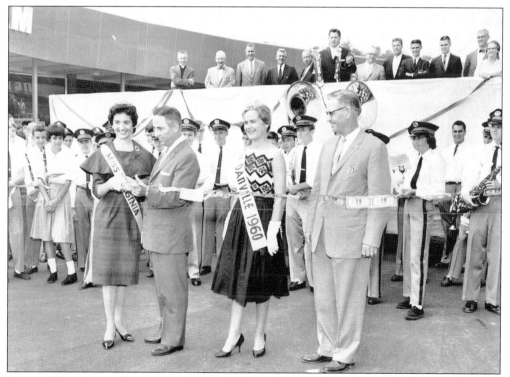

Mayor Julian Stinson (front, second from left) cuts the tape during Riverside Shopping Center's grand opening on August 24, 1960.

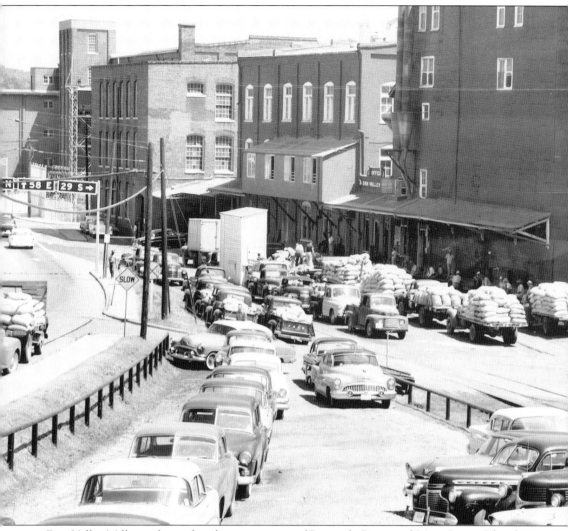

Dan Valley Mills was located at the intersection of Riverside Drive and Main Street. The above photo depicts trucks loaded with wheat sitting in line waiting to offload in 1959.

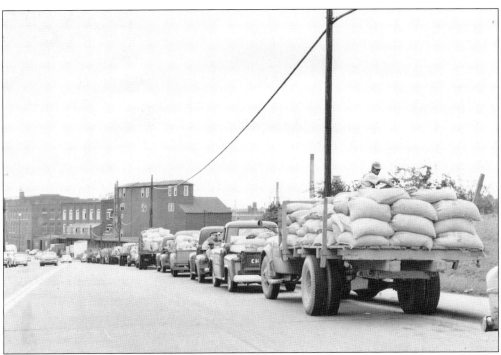

This 1958 photo shows the congestion along Riverside Drive caused by pickup trucks and flatbeds bringing wheat to Dan Valley Mills.

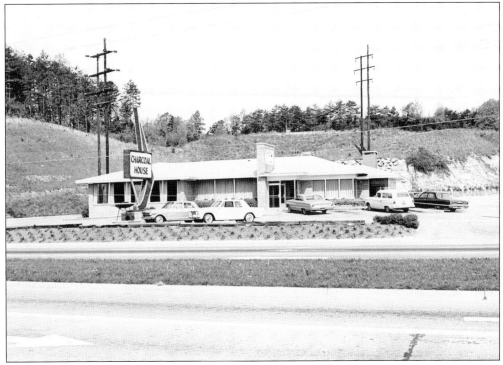

The Charcoal House was a popular local eatery from 1958 to 1981. It was located at 3426 Riverside Drive.

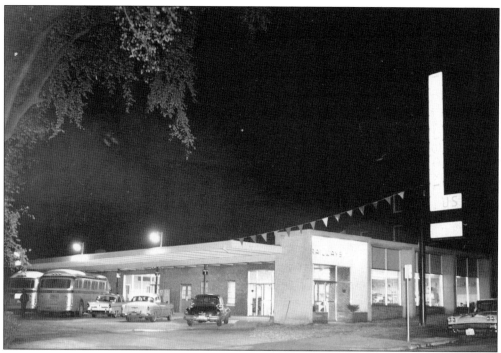

The Trailways Bus Terminal opened on Main Street in Danville in October 1959. Greyhound and local lines also served Danville.

Trailways personnel pose during the grand opening of the terminal on October 12, 1959.

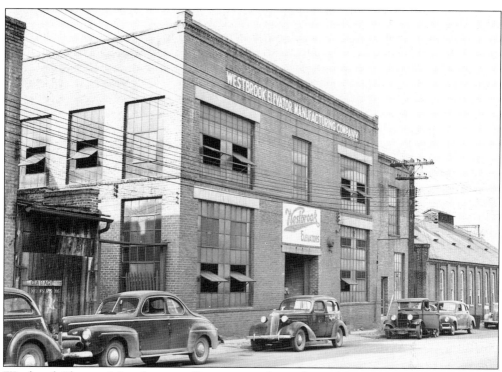

Westbrook Elevator Manufacturing Company was located at 410 Spring Street in Danville.

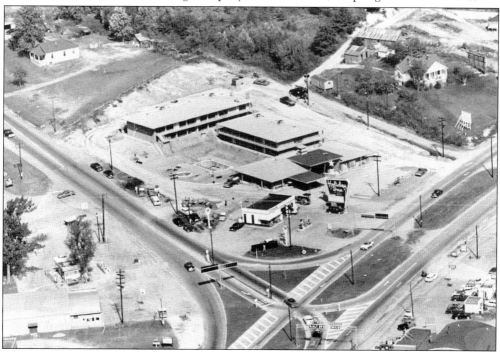

Holiday Inn was built at the corner of Riverside Drive and Piney Forest Road. This photo, taken in October 1959, shows the hotel under construction. Today, it continues to operate as the Ramada Inn Stratford.

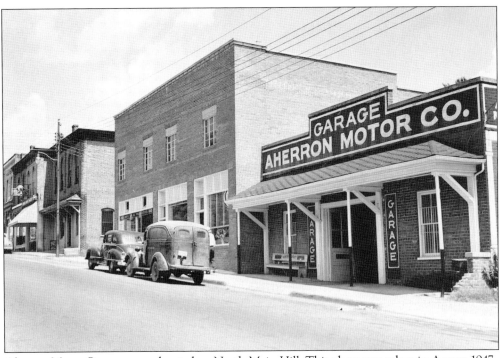

Aherron Motor Company was located on North Main Hill, This photo was taken in August 1947.

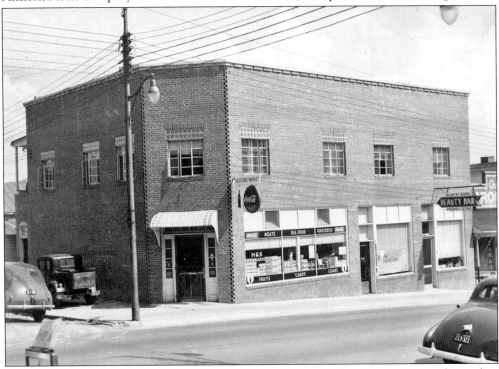

H&S Food Market, Sheffield's Barber Shop, and Klip N' Kurl Beauty Bar were located at the corner of North Main Street and Meade Alley. The beauty bar sign reflects a four-digit telephone number in the 1948 photo above.

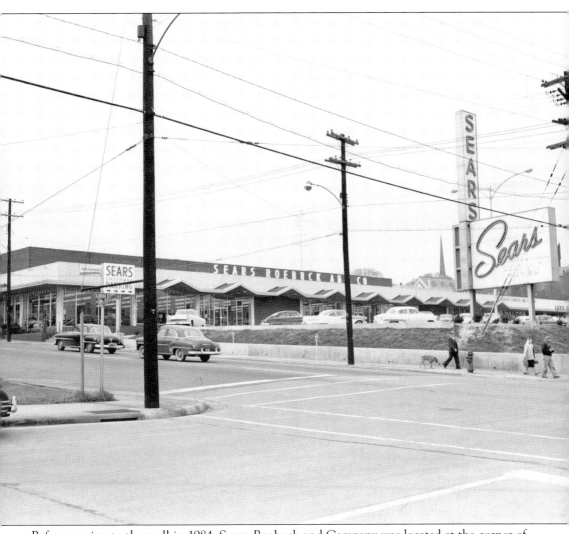

Before moving to the mall in 1984, Sears, Roebuck and Company was located at the corner of Ridge and Loyal Streets in downtown Danville. This photo was taken in 1959.

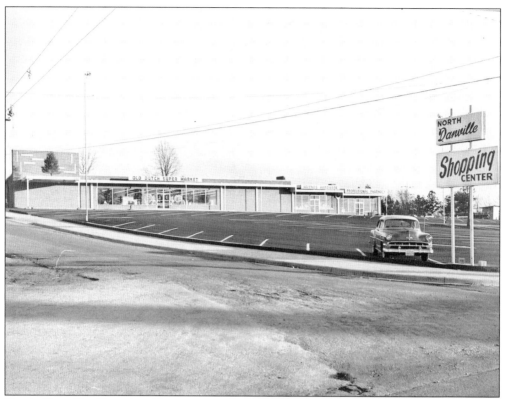

North Danville Shopping Center opened in December 1959. Its stores were Old Dutch supermarket, Haynes Hardware, and Professional Pharmacy. Old Dutch continues to operate a grocery store there today.

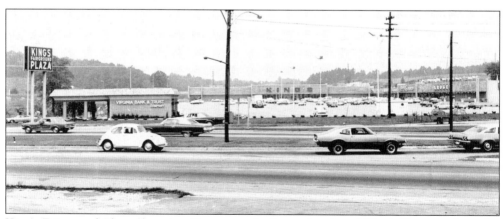

King's Fairground Plaza Shopping Center was built on the site of King's Fairground, at the intersection Riverside Drive and Piney Forest Road. The anchor stores were King's Department Store, Super X Drugs, and Kroger's grocery.

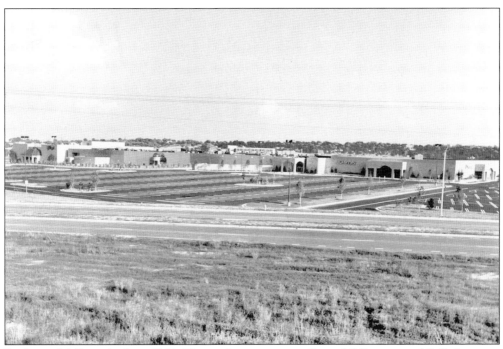

Piedmont Mall was built in 1984. The anchor stores were Sears, JC Penney, and Belk Leggett.

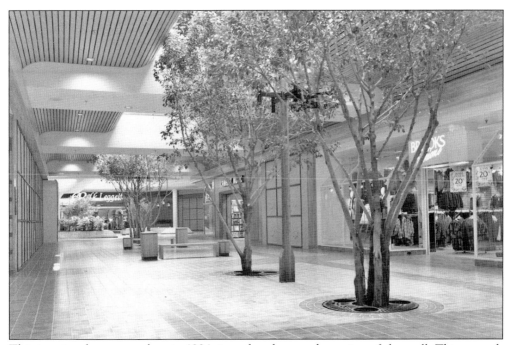

This interior photo was taken in 1984, just after the grand opening of the mall. This ground-floor view shows Brooks Fashions, Camelot Music, and Belk Leggett.

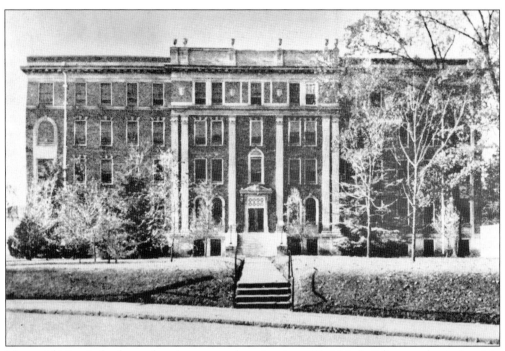

Memorial Hospital relocated to its present location in 1925. This building was completed in 1926 and faced South Main Street. Prior to this, the hospital, which dates back to 1886, was located on South Ridge.

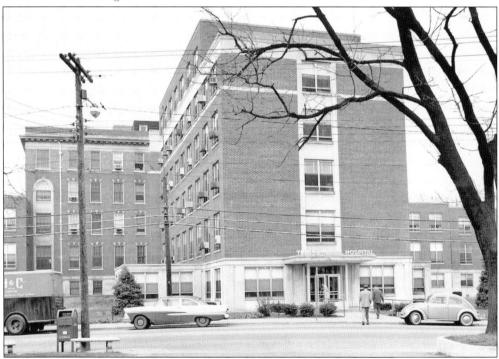

There have been additions to Danville's hospital, which today is known as Danville Regional Medical Center. This photo was taken in 1959.

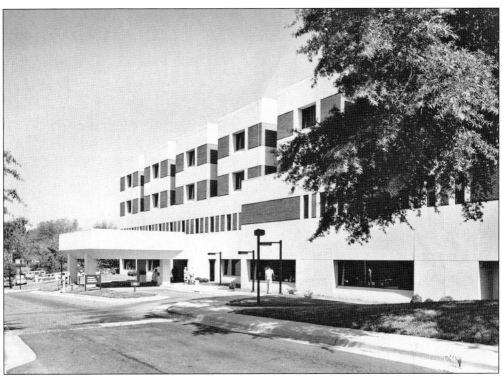

This photo shows Danville Regional Medical Center as it appeared in 1985, when it was known as Danville Memorial Hospital.

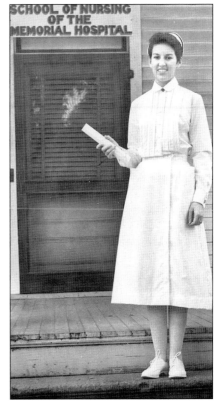

The hospital has operated a school of nursing since 1898. This undated photo shows a nurse after receiving her diploma.

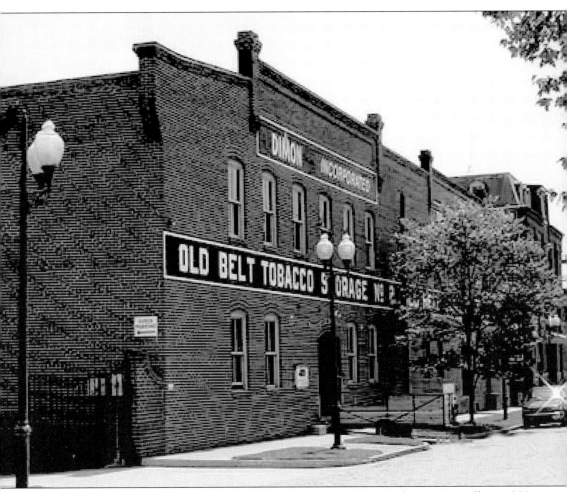

Luna Innovations located its Nanotechnology Manufacturing facility in Danville in 2004. The company chose to renovate a 40,000-square-foot tobacco warehouse to produce its nanomaterials.

Six

EXERCISE DRAGONHEAD

In October 1959, during the height of the Cold War, the U.S. Army conducted a large-scale training exercise in Danville. The exercise, named Dragonhead, saw aggressor forces capture the city and imprison local leaders before Danville was liberated by airborne troops of the famed 82nd Airborne Division. The documentary video of this exercise is available to be checked out from the Danville Public Library.

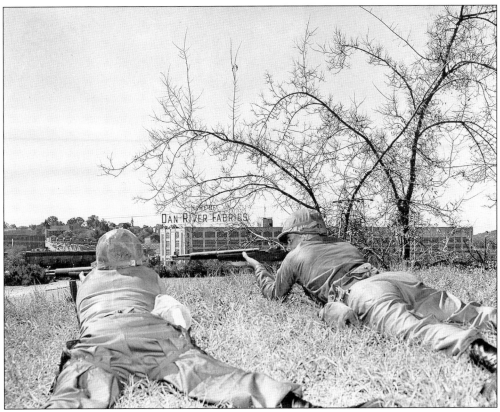

Soldiers of the 82nd Airborne Division participated in the Strategic Army Corps's Exercise Dragonhead in 1959.

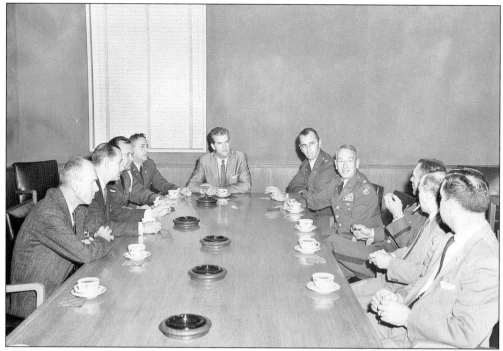

Congressman W.C. "Dan" Daniel discussed Exercise Dragonhead with local leaders and army personnel prior to the exercise beginning.

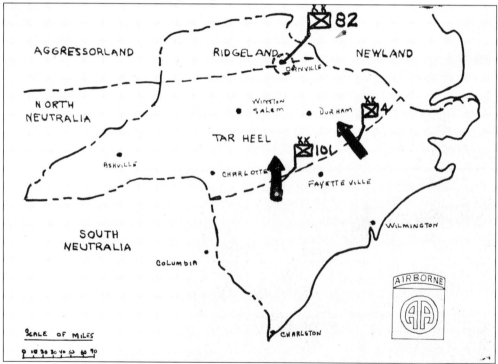

Danville's role in the exercise was to serve as the capital city of Tarheel, a friendly nation invaded by forces of Ridgeland, a country bordering Tarheel on the north.

A helicopter dropped propaganda leaflets
on the city during the exercise.

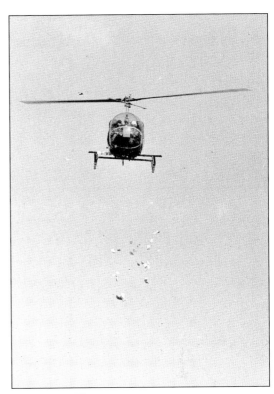

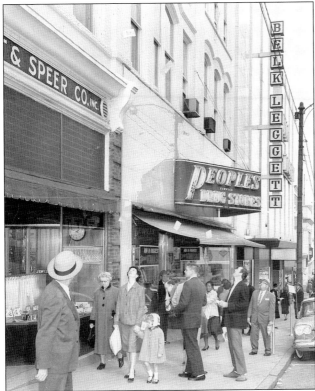

Danville citizens watched
leaflets fall on Main Street in
downtown Danville.

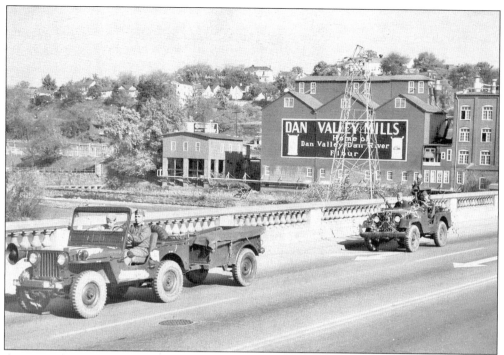

Aggressor forces moved to occupy Danville across Main Street Bridge. Dan Valley Mills is in the background of the photo.

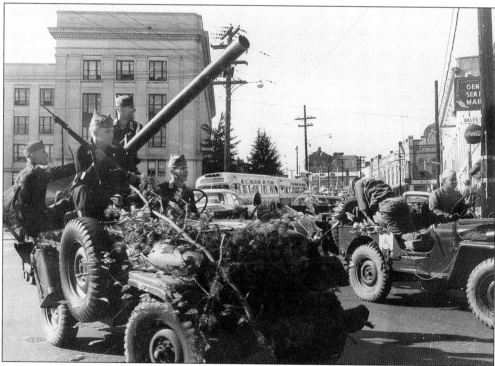

Enemy troops armed with guns mounted on Jeeps patrolled the streets of Danville. City hall is to the left, and Gentry Seafood Market is on the right.

Aggressor forces raised their flag above the city after capturing Danville. Police and citizens stood by as the event unfolded.

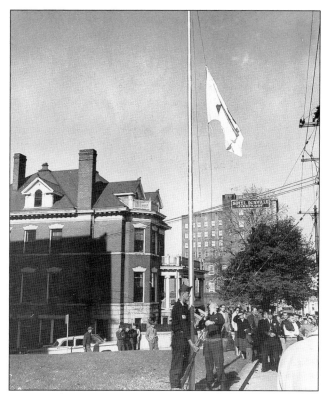

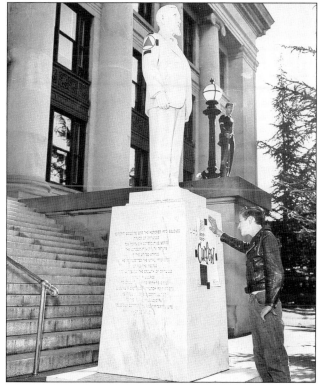

Raleigh Reynolds reads a sign posted on the statue of Mayor Harry Wooding outside of city hall. SFC Oscar White stands guard near the light post.

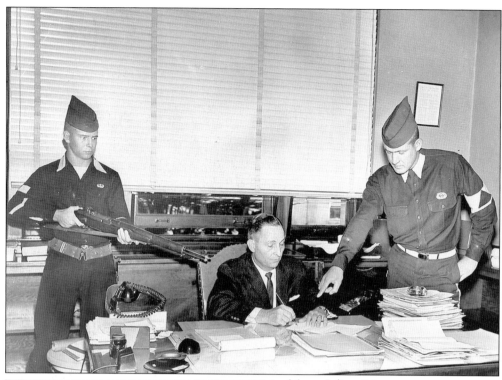

Mayor Julian Stinson was forced to sign over the city as aggressors took over his office.

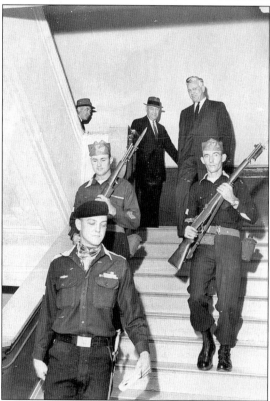

City Manager T. Edward Temple, Finance Director Randolph Hall, and Superintendent of Schools O.T. Bonner were placed under arrest and escorted down the steps of city hall.

Danville police chief J.C. Garrett was relieved of his pistol as aggressors took control of police headquarters.

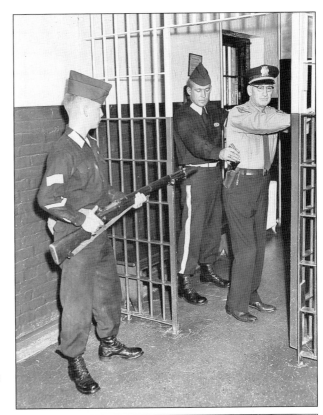

A hasty prisoner-of-war camp was established behind city hall to house local leaders.

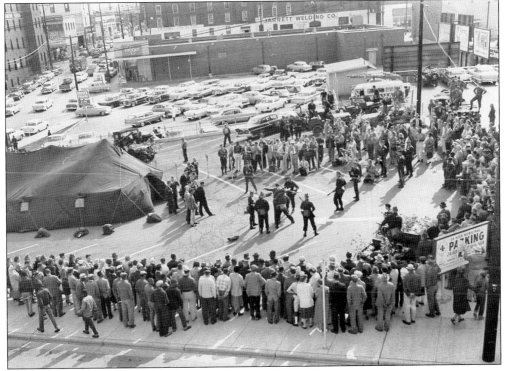

An aggressor guard was posted outside of the Danville *Register and Bee* building in downtown Danville.

Newspaper workers stood by as enemy troops smashed the presses of the *Register and Bee.*

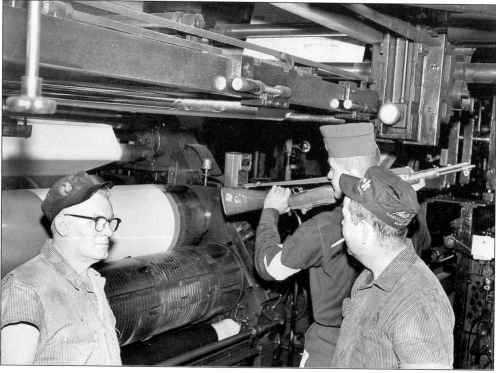

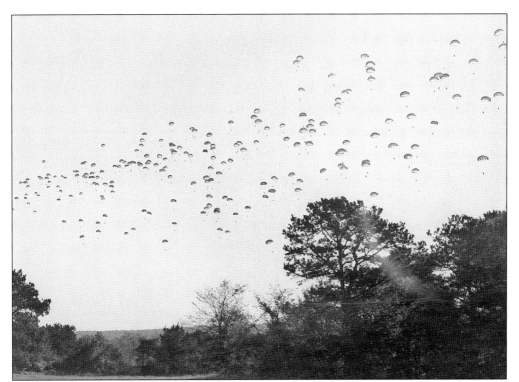

Airborne troops of the 82nd Airborne Division were dropped near the outskirts of Danville to liberate the city.

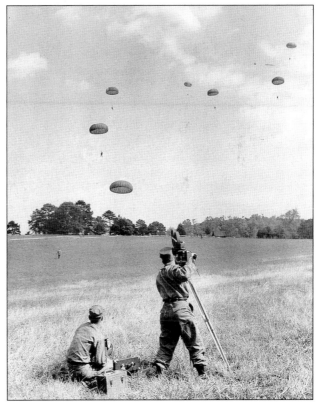

Documentary videographers recorded the action of the jump. Their efforts allow the exercise to be viewed today on a DVD that can be checked out from the Danville Public Library.

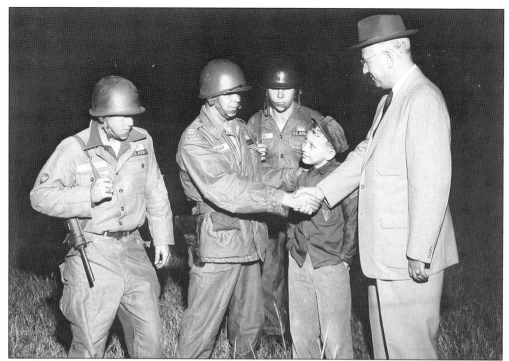

T. Edward Temple, Danville city manager (at right), greeted a captain from the 82nd Airborne Division before the attack to retake Danville began.

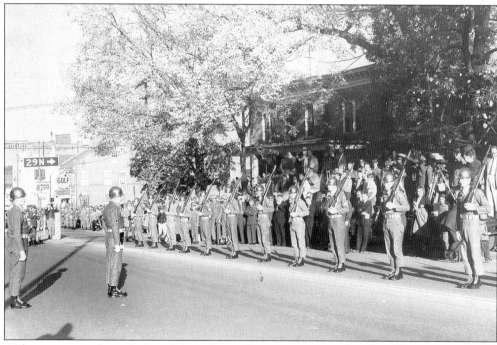

Airborne troops formed along Main Street for a victory parade after liberating Danville. Resistance by the enemy proved determined, but Strategic Army Corps forces utilized tactical nuclear weapons to break up Ridgeland forces.

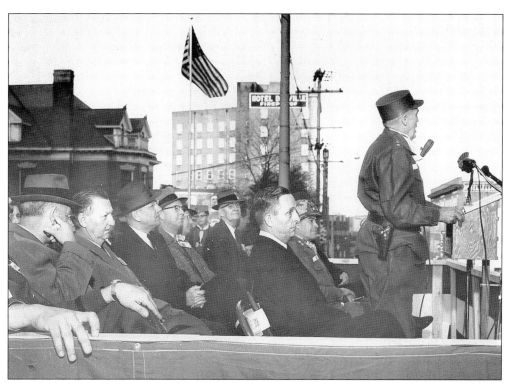

Mayor Julian Stinson and other local leaders sat in a reviewing stand during the victory parade following the battle to retake Danville.

Sgt. Everoe V. Duell, Spc. Floyd Comerford, and S. Sgt. James Williams of the 187th Airborne Battle Group take a break during Exercise Dragonhead.

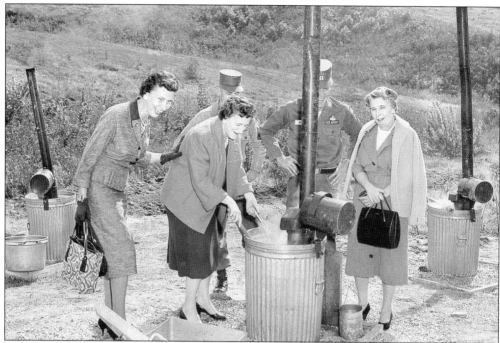

Evelyn Shelton, cafeteria manager at Robert E. Lee Junior High School; Pearl Wyatt, director of cafeterias for the Danville School Board; and Sarah B. Pearson, cafeteria manager at George Washington High School, receive a hands-on demonstration of the army's mess facilities.

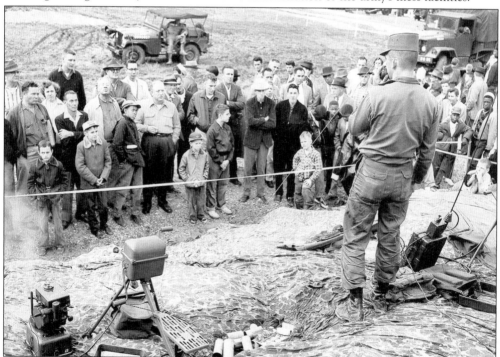

SFC John Boyd explains radio equipment to Danville's citizens with a display of military equipment during the exercise.

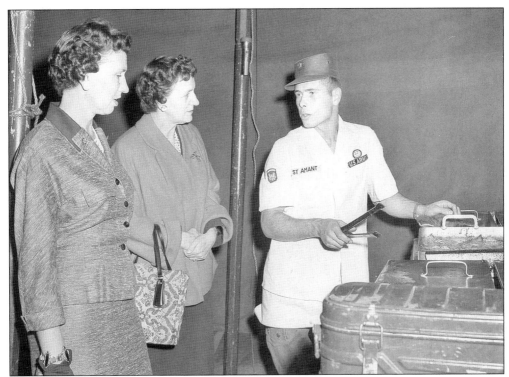

Evelyn Shelton and Sarah
Pearson are briefed on the
operation of an army chow hall.

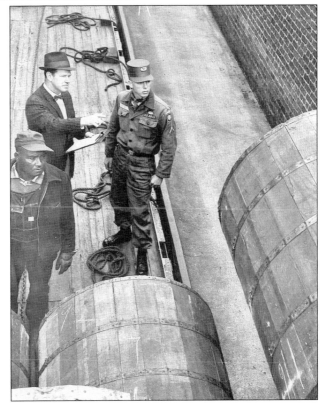

The exercise also provided
the opportunity for soldiers to
learn first-hand about Danville's
tobacco operation. F.S.
Fitzgerald, general foreman for
the Liggett and Myers Tobacco
Company, explained the
stemming and drying process to
PFC Jerry Jeffcoat.

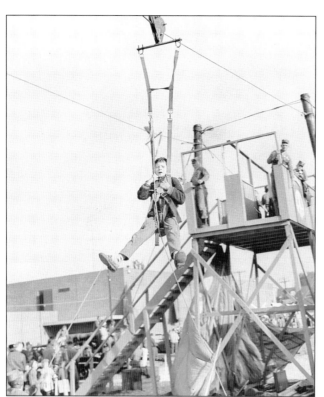

A special attraction of the military equipment display was a "kiddie jump tower." This 15-foot tower allowed kids to experience a simulated airborne jump and receive their "wings."

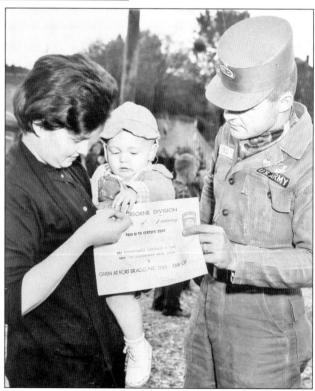

Linda Revis holds her son, Joey, as he receives his honorary wings from S. Sgt. Jerry Price.

Seven

PEOPLE, PLACES, AND EVENTS

For more than 280 years, individuals have lived in the area that is now known as Danville. Many changes have taken place since the small settlement was first established. Roads, bridges, churches, and schools have been built. Businesses have been established and Danville's citizens have made a difference. Today, Danvillians can take great pride in our community because of the past and can focus on the future because of the possibilities that lie ahead.

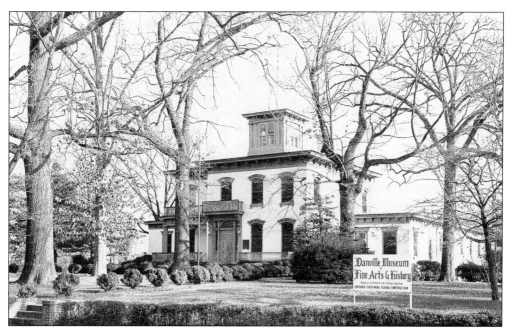

Sutherlin Mansion is known as the Last Capital of the Confederacy. It was here that Confederate President Jefferson Davis held his last cabinet meeting and issued his last official proclamation. Today, Sutherlin Mansion serves as the Danville Museum of Fine Arts and History.

Danville native Wendell Scott was the first African American to win a major NASCAR race. On December 1, 1963, Wendell Scott won a 100-lap event in Jacksonville, Florida. He raced on the sport's top circuit from 1961 to 1973, competing in 495 races. Richard Pryor portrayed Scott in the 1977 movie *Greased Lightning*. Scott passed away in 1990.

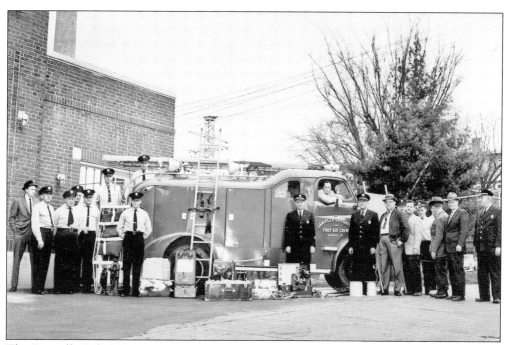

The Danville Life Saving Crew can trace its origins back to 1945. This 1959 photo shows the crew's new crash truck. Today, this dedicated group of individuals continues to serve our community.

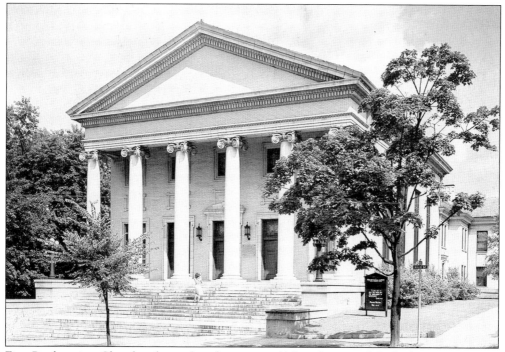

First Presbyterian Church is located at the corner of Main Street and Sutherlin Avenue. This church was built in 1912. It was the fourth church built by this congregation, which traces its roots back to 1826.

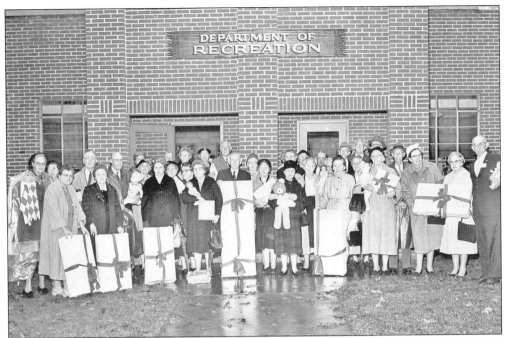

The Danville Parks, Recreation, and Tourism Department maintains more than 50 municipal recreational facilities. Pictured here are senior citizens posing during the holiday season at the Green Street Park Recreation Center.

The Langhorne House, located at 117 Broad Street, is the birthplace of Nancy Langhorne Astor and Irene Langhorne Gibson. The home is currently being restored as a permanent museum to these two sisters. Nancy became the first woman to sit in the British House of Commons, and Irene was the inspiration for the famous Gibson Girl painting.

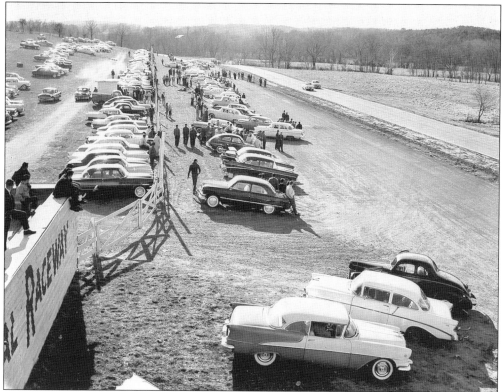

Virginia International Raceway is located close to the city of Danville. It first opened as a racetrack in August 1957. The track closed in October 1974. After 25 years, the facility reopened in 2000, and today it is one of the premier road courses in the United States. This 1959 photo shows drag races being held at the track.

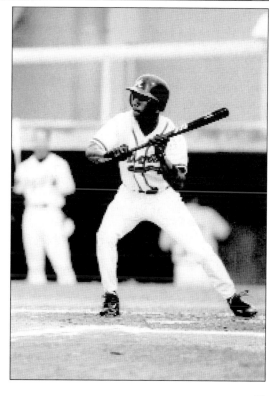

The Atlanta Braves moved their rookie team from Pulaski, Virginia, before the start of the 1993 season. It was the first time that professional baseball had been played in Danville since the Danville Leafs, a New York Giants affiliate, played their last season in 1958. Angelo Burrows is shown here preparing to bunt.

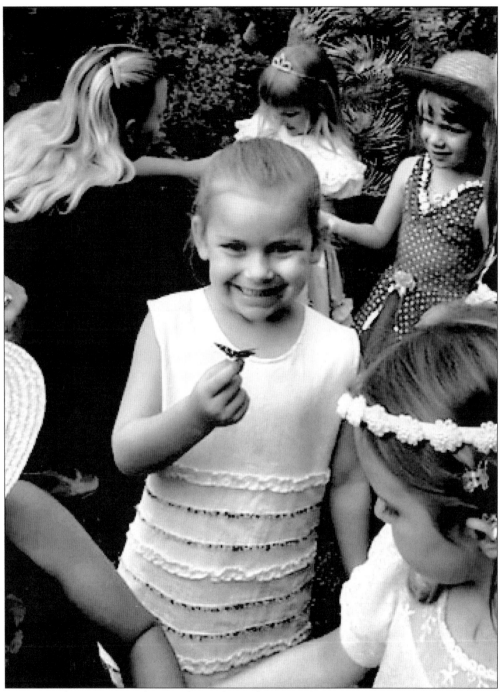

Virginia Rebecca Yeatts releases a butterfly at the Danville Science Center Butterfly Station and Garden in 2002.

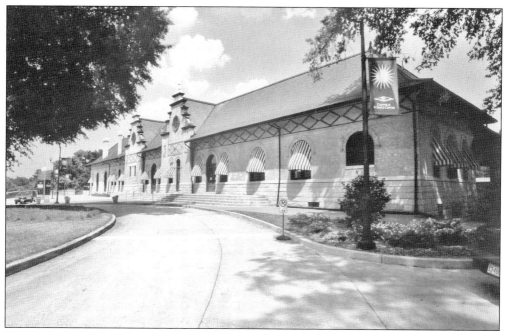

The Danville Science Center is located at the Crossing at the Dan in the Southern Railway Passenger Station, which was built in 1899. It is listed with the Virginia Landmarks Commission and on the National Register of Historic Places.

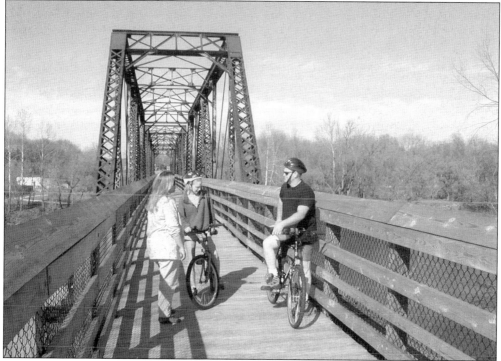

The Riverwalk Trail offers more than three miles of handicapped-accessible trails for bicycles and pedestrians. The trail begins at the Crossing at the Dan over a converted railway trestle.

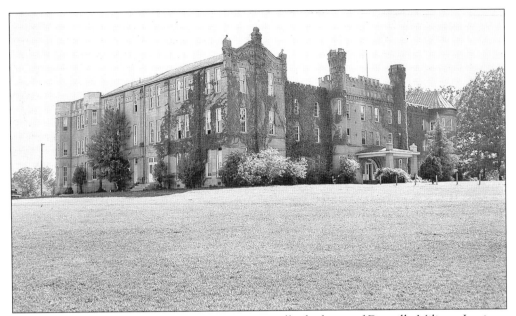

The Castle, as it was commonly known, was originally the home of Danville Military Institute and, later, the Virginia Tech Extension, which became Danville Community College. The Castle was built in 1890. It was located at the corner of Kemper Road and South Main Street before being torn down in 1974.

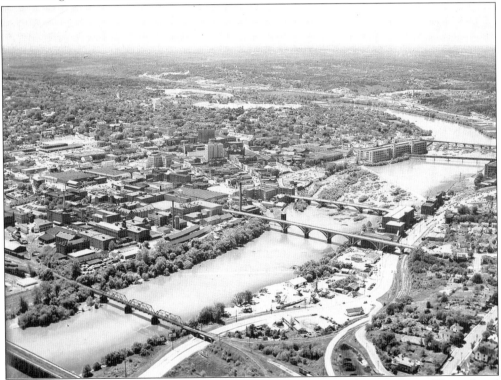

This aerial photo taken in 1957 shows the many bridges crossing the Dan River. The railroad trestle is now part of the Riverwalk Trail.

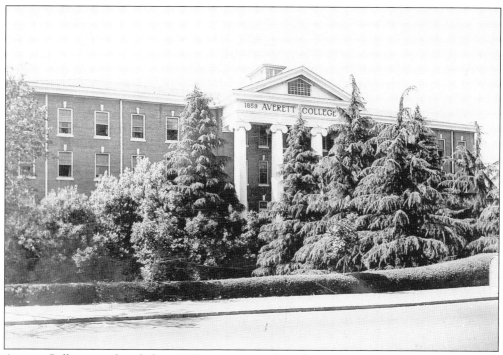

Averett College was founded in 1895 as a junior college for women. Today, Averett University is a four-year, co-ed private university.

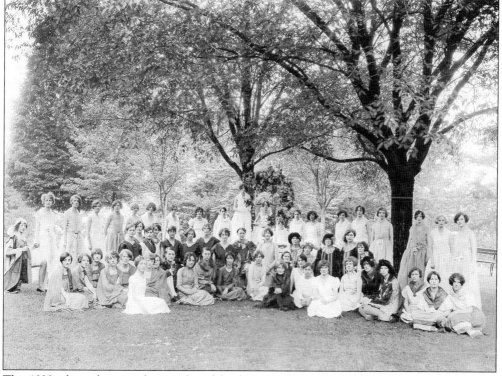

This 1920s photo shows students gathered for the annual May Day celebration at Averett College.

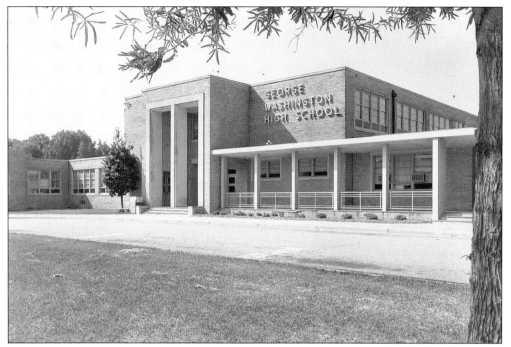

George Washington High School was built in 1957 and has graduated generations of Danville students as Cardinals or Eagles since that time.

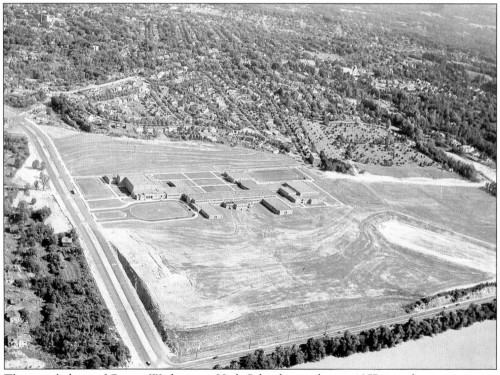

This aerial photo of George Washington High School was taken in 1957 just after construction was completed. Notice that the Aiken Street Bridge did not exist at the bottom of the photo.

Sacred Heart Church was completed in 1939 at 288 West Main Street. Today it is a private residence, and the church is located on Central Boulevard.

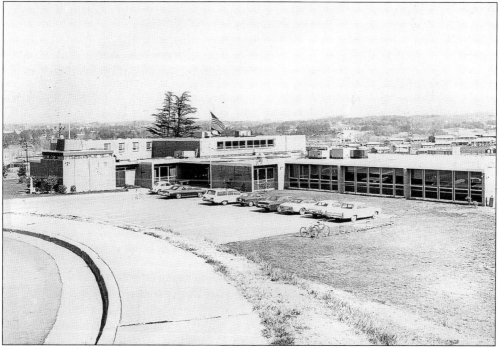

Sacred Heart School was founded in 1953. It was Danville's first private school and remains the only Catholic school in the community.

The Occupation Technical Building at Danville Community College was renamed the Charles R. Hawkins Center for Engineering and Industrial Technology in 1997. Hawkins served in the Virginia House of Delegates from 1982 through 1992 and in the Virginia Senate from 1992 to the present.

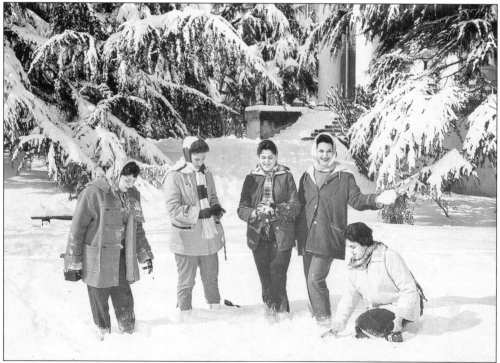

Averett students from Cuba enjoy their first snow in 1957 outside of the Administrative Building on West Main Street.

Stratford College was run as an all-girls college from 1930 to 1974. In 1990, the campus was renovated and became Stratford House, a retirement community.

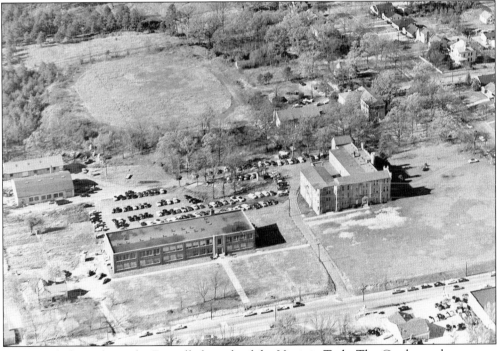

This aerial photo shows the Danville branch of the Virginia Tech. The Castle can be seen on the right side of the photo.

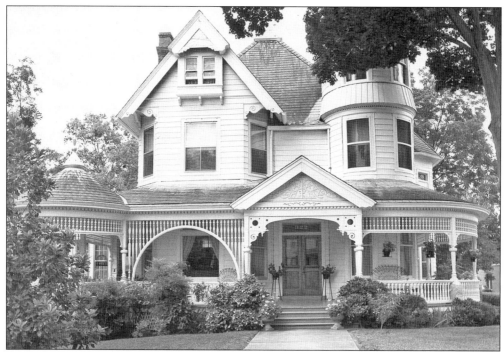

Built at the turn of the century, this house at 322 West Main Street is one of the many houses that make up "Millionaire's Row."

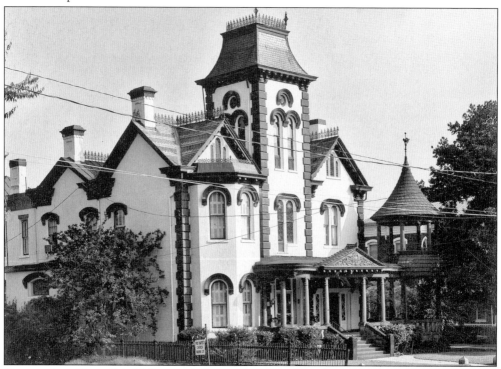

Homes along Danville's Millionaire's Row are some of the finest examples of Victorian and Edwardian architecture in the South.

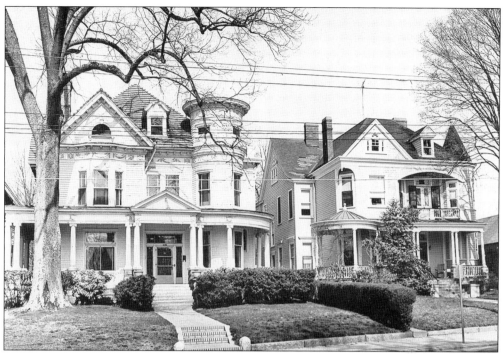

The houses along the historic district on Main Street in Danville were built during the "Gilded Age," when the community prospered from the success of the tobacco and textile markets.

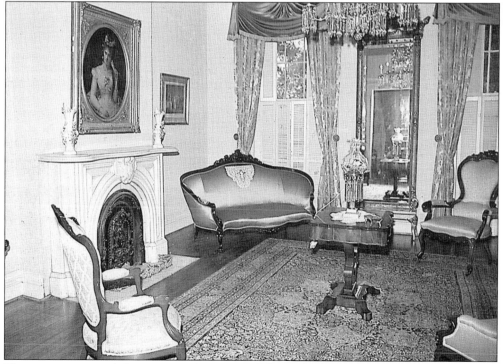

This picture-postcard shows an interior view of the parlor located in Sutherlin Mansion on West Main Street.

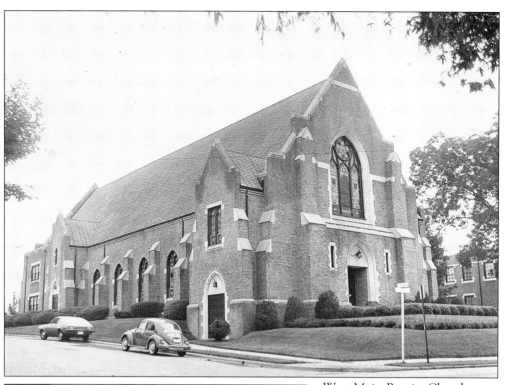

West Main Baptist Church was built in 1941 near Averett University.

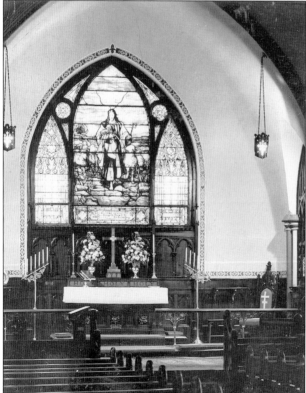

This stained-glass window is in the Episcopal Church of the Epiphany, located at the corner of Main and Jefferson Streets. The church contains the second largest Andover organ in the world.

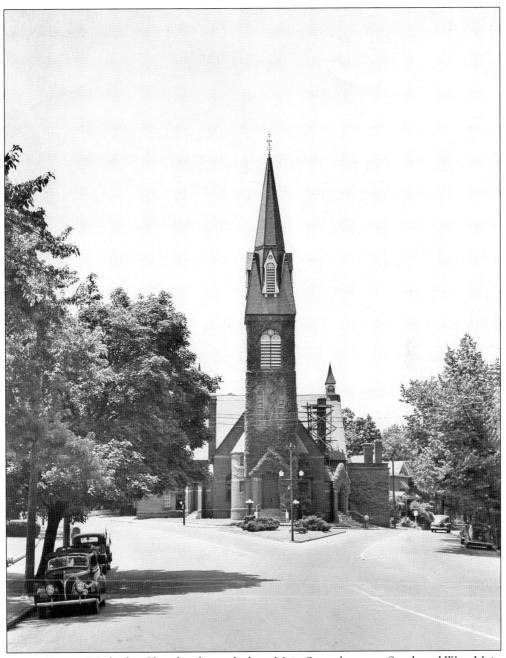

Mount Vernon Methodist Church is located where Main Street becomes South and West Main Streets. It was built in 1885.

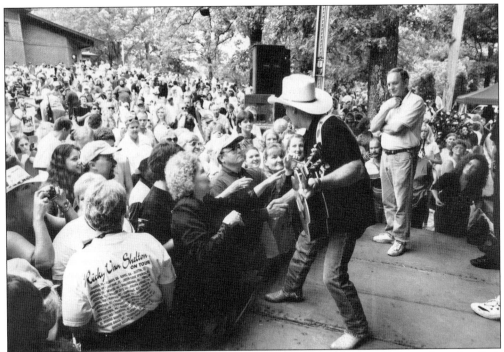

Ricky Van Shelton performs before a large crowd at Danville's annual Festival in the Park celebration. Parks, Recreation, and Tourism director John Gilstrap looks on at his right.

Festival in the Park began in 1974 to celebrate the arrival of spring. Today, the event includes Pigs in the Park, a barbeque contest that crowns the state champion.

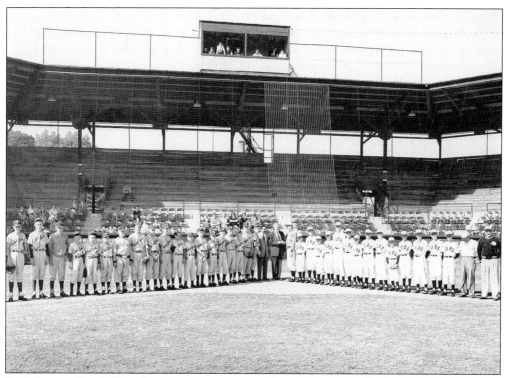

Little League Baseball has been a major recreational activity in Danville for more than 50 years. This photo shows Mayor Curtis V. Bishop congratulating the players before the All-Star Babe Ruth game at League Park in 1954.

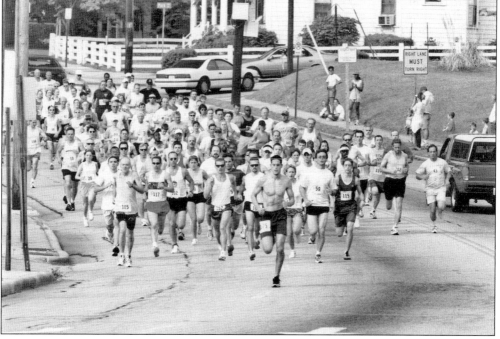

Numerous 5K and 10K events take place in Danville each year.

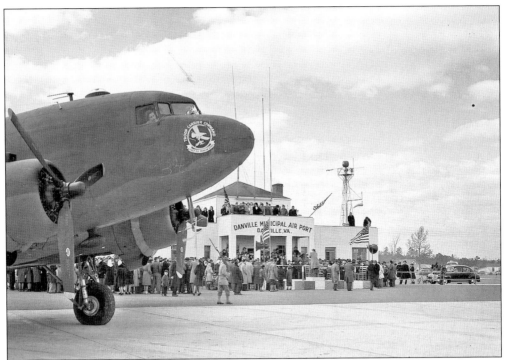

Danville Municipal Airport hosted the Army Exhibition Team Air Show on October 12, 1946.

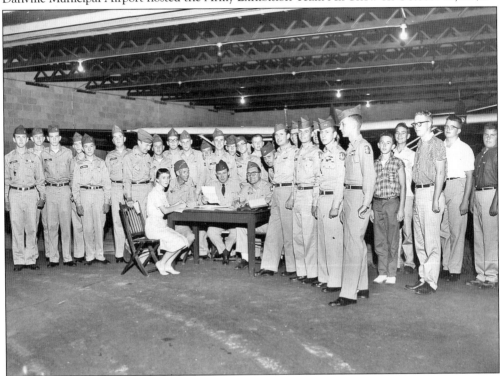

The Civil Air Patrol continues to serve the region today from Danville Regional Airport. This 1958 photo shows cadets and leaders.

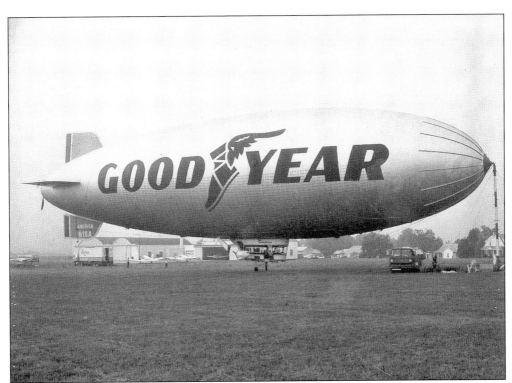

The Goodyear blimp was a familiar sight in the skies over Danville in the early 1970s. It is shown here tethered at Danville Regional Airport.

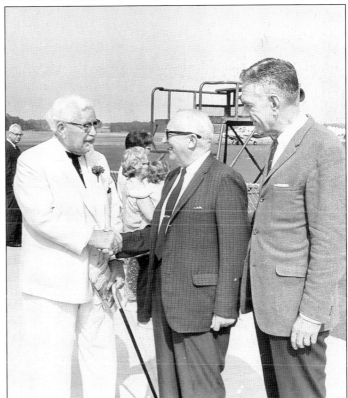

Mayor W.C. McCubbins (center) and William Rickman (right) of the chamber of commerce greeted Col. Harland B. Saunders at the airport during his visit to Danville in 1967.

Danville native Herman Moore was selected to the Pro-Bowl four times while playing wide receiver for the Detroit Lions. Moore played college football at the University of Virginia.

Buddy Curry was the NFL's Defensive Rookie of the Year in 1980. He was a football standout at the University of North Carolina and George Washington High School.

Johnny Newman was drafted into the NBA in 1986. He played his college basketball at the University of Richmond and was a star at George Washington High School.

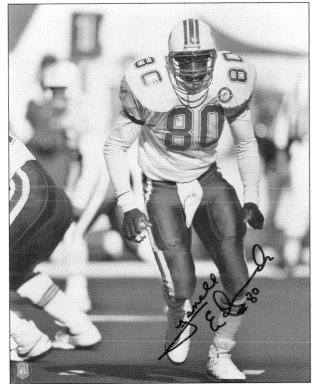

Danville native Ferrell Edmunds was selected to the Pro-Bowl two times in his NFL career. He played his college football at the University of Maryland, where he remains the most prolific tight end in school history, with 101 catches for 1,641 career yards.

The City Auditorium was the site of the 1958 Debutante Ball. The auditorium is located in the old city armory, built in 1931.

The easy-flowing Dan River provides a tranquil recreational outlet for fishing, canoeing, or simply relaxing.

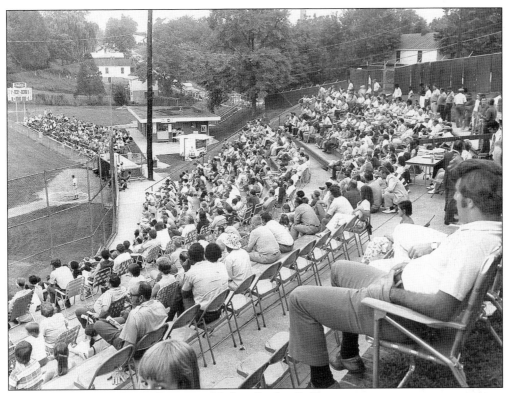

Fans enjoy a summer baseball game at Market Garden Field.

Youth football remains a popular outdoor recreational activity, along with basketball, baseball, and soccer.

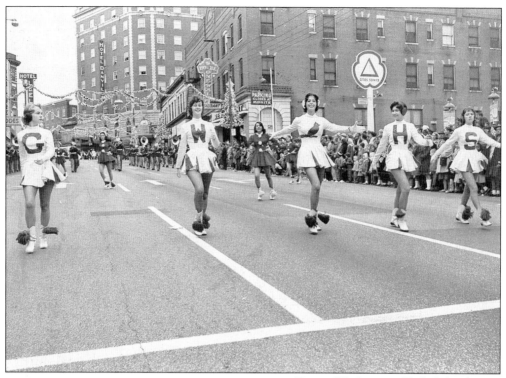

George Washington High School cheerleaders march in the 1959 Christmas Parade. The mascot in 1959 was the cardinal.

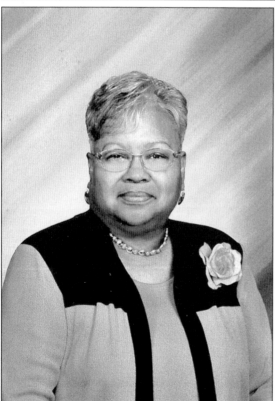

Ruby Archie was elected to the Danville City Council in 1994. She served as vice mayor from 1996 to 1998 and was elected Danville's first female mayor in 1998, serving until 2000. Archie continues to serve the citizens of Danville as the city's only councilwoman.

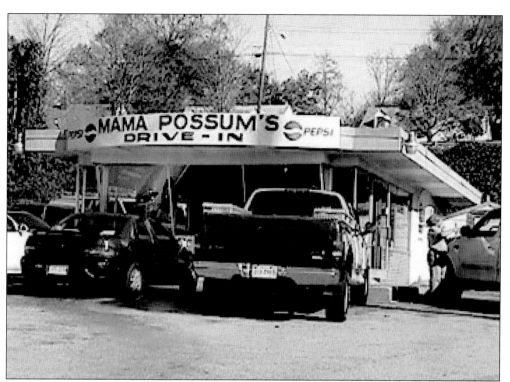

Mama Possum's Drive-In is a Danville landmark. Yvonne and Caroll Gunnell bought the restaurant in 1977. The restaurant is named after Yvonne's CB handle. Eddie Blachura has owned and operated the restaurant since 2000.

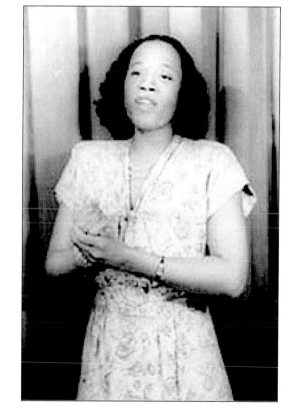

Soprano Camilla Williams was born in Danville in 1922. She was the first African American to sign a contract with a major American opera company, the New York City Opera. Her debut with the company was in the title role of *Madame Butterfly*.

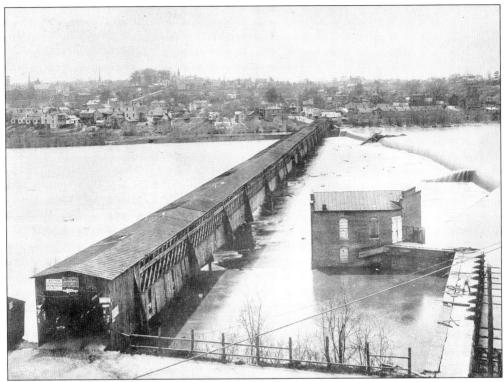

A large wooden-covered bridge spanned the Dan River at the present day Union Street Dam.

Union Street Bridge today follows the same path across the river.

Nancy Langhorne was born in Danville in 1879. She later became the Viscountess Astor and was the first woman to sit in the British House of Commons. She made two official visits to Danville, the first in 1922 and the second in 1946. This photo is from her 1946 visit.

Wilbur Clarence "Dan" Daniel was a popular United States congressman for 20 years. He began his career as an hourly employee at Dan River Mills in 1939. In 1956, he became the National Commander of the American Legion. He was elected in 1968 as the president of the Virginia State Chamber of Commerce. Dan Daniel Park is named in his honor.

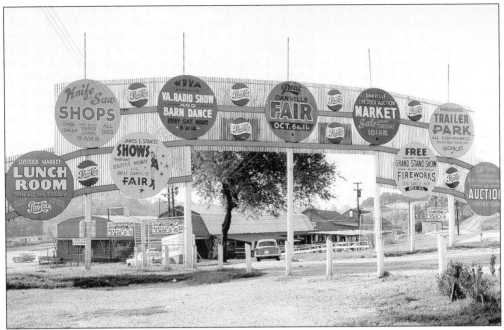

This 1959 photo shows the entrance of Danville Fairgrounds, which today is King's Fairgrounds Plaza.

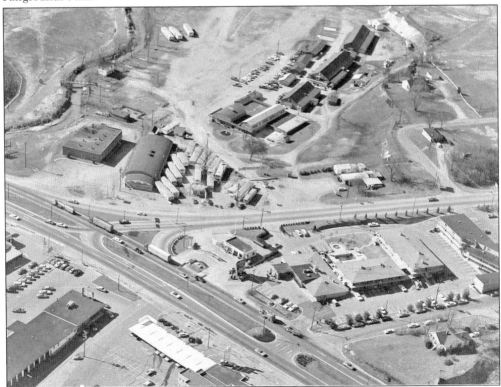

This 1972 aerial photo shows the fairgrounds at the top of the photo and the Holiday Inn (present-day Ramada Stratford) at the bottom.

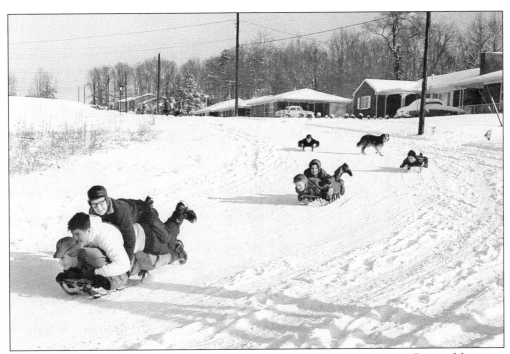

Danville's four distinct seasons offer year-round recreational opportunities. Pictured here are children sleigh-riding at Temple Terrace in 1958.

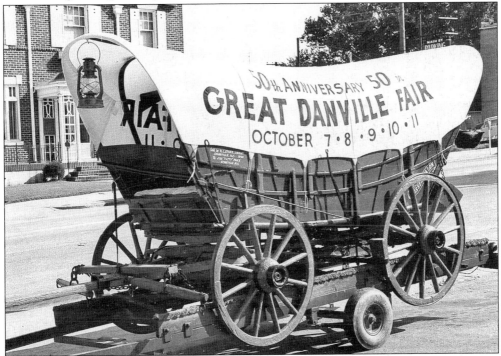

In celebration of the 50th anniversary of the Greater Danville Fair in 1958, a covered wagon was decorated. It was parked in front of Townes Funeral Home, which became the chamber of commerce in 1993.

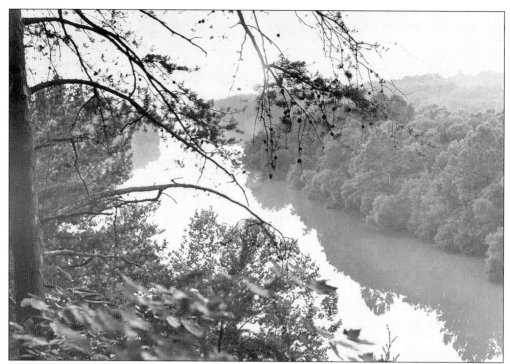

The Dan River provides a bountiful supply of water to the community as well as an abundant source of recreational activity and scenic views.

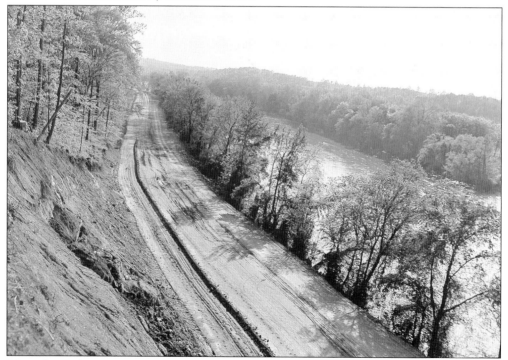

This photo shows Memorial Drive under construction in 1952 along the banks of the Dan River.

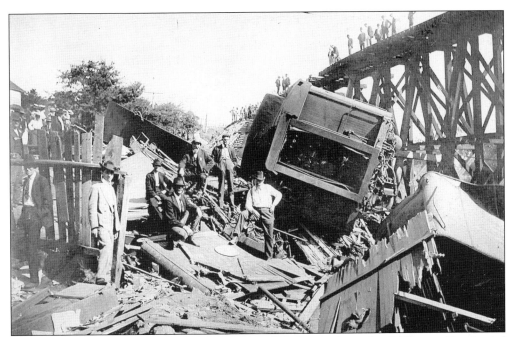

On September 27, 1903, the mail train No. 97 left the track at the Stillhouse Trestle and crashed into the creek below. The crash killed engineer Joseph "Steve" Broady and 10 other men. The wreck would probably have been forgotten had it not been for the song of the same name that became country music's first single to sell one million copies.

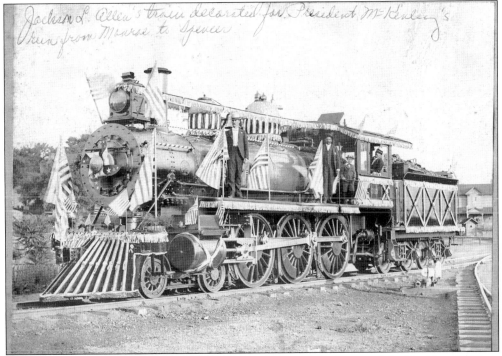

Jackson L. Allen's train was photographed in Danville while decorated for President William McKinley's run from Monroe to Spencer, North Carolina.

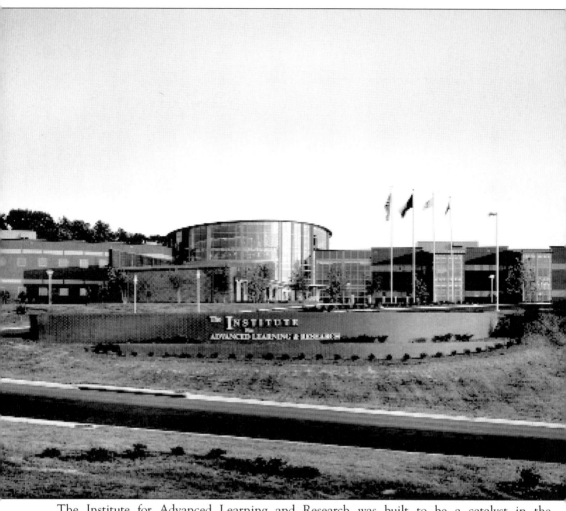

The Institute for Advanced Learning and Research was built to be a catalyst in the transformation of the economy in Southside Virginia. The institute was built by Danville and Pittsylvania County using monies from the Virginia Tobacco Indemnification and Community Revitalization Commission. The facility, which opened in 2004, is a partnership between Virginia Tech, Averett University, and Danville Community College.